The

Bride's

Guide
to Wedding Photography

Steve Sint

Book Design and Layout: Sandy Knight
Cover Designer: Barbara Zaretsky
Photography by Steve Sint unless otherwise specified.
Editorial Assistance: Delores Gosnell

Library of Congress Cataloging-in-Publication Data
Sint, Steve, 1947-
 The bride's guide to wedding photography / Steve Sint.
 p. cm.
Includes index.
 ISBN 1-57990-481-5 (pbk.)
 1. Wedding photography. 2. Weddings--Planning. I. Title.
TR819.S54 2004
778.9'93925--dc22

 2003022436

10 9 8 7 6 5 4 3 2

Published by Lark Books, a division of
Sterling Publishing Co., Inc.
387 Park Avenue South, New York, NY 10016

Distributed in Canada by Sterling Publishing,
c/o Canadian Manda Group, 165 Dufferin Street
Toronto, Ontario, Canada M6K 3H6

Distributed in the U.K. by Guild of Master Craftsman Publications Ltd., Castle Place,
166 High Street, Lewes, East Sussex, England BN7 1XU
Tel: (+ 44) 1273 477374, Fax: (+ 44) 1273 478606
Email: pubs@thegmcgroup.com, Web: www.gmcpublications.com

Distributed in Australia by Capricorn Link (Australia) Pty Ltd.,
P.O. Box 704, Windsor, NSW 2756 Australia

If you have questions or comments about this book, please contact:
Lark Books, 67 Broadway, Asheville, NC 28801
(828) 253-0467

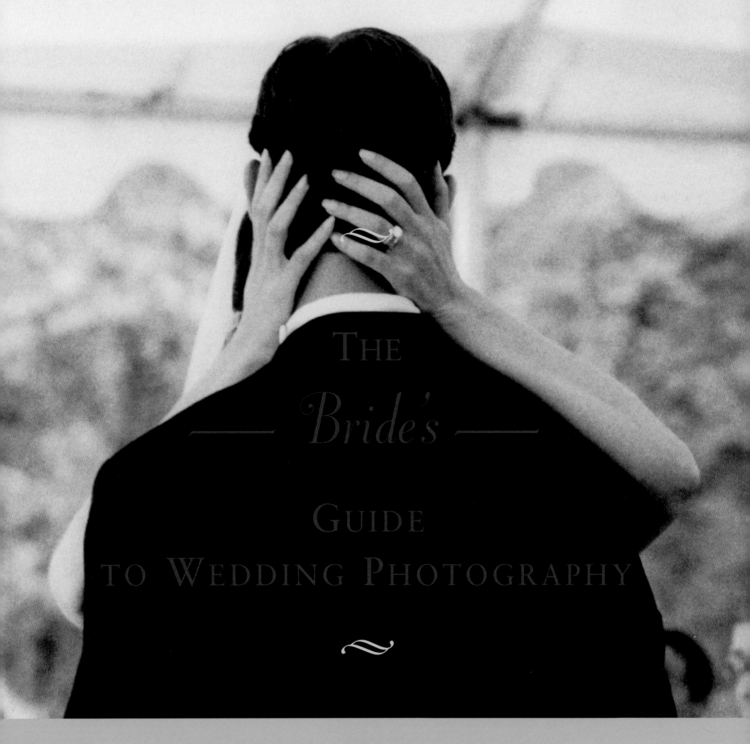

The Bride's

Guide

to Wedding Photography

Steve Sint

LARK BOOKS

A Division of Sterling Publishing Co., Inc.
New York

ACKNOWLEDGMENTS

THANKS TO THE PHOTOGRAPHERS WHO SO KINDLY CONTRIBUTED TO THIS BOOK

Freed Photography, freedphoto.com, (301) 652-5452

Franklin Square Photographers, fsphoto.com, (516) 437-1055

Glenmar Photographers, glenmarphotographers.com, (973) 546-3636

In-Sync Photography, insyncphotography.com, (908) 522-1801

Marcia Mauskopf, marciaphoto.com, (805) 688-4033

Jerry Meyer Studio, jerrymeyerstudio.com, (718) 591-7722

The Photographer's Gallery
Len, Davide, and Jacqui DePas
thephotographersgallery.net, (202) 362-8111

Photography Elite, Inc., photoeliteinc.com, (718) 491-4655

Rich Pomerantz Photography, richportraits.com, (860) 355-3356

Jan Press Photomedia, janpress.com (973) 992-8812

Mark Romine Photography, romineweddings.com, (309) 662-4258

Frank Rosenstein Photography, rosensteinphoto.com, (206) 706-0462

George Weir Photography, georgeweir.com, (877) 934-7368

Michael Zide Photography, michaelzide.com, (413) 256-0779

FRONT COVER
Photo by the Author
Hair and Make-up: Filis Forman, New York City, ffmakeup@aol.com
Headpiece: Denise Leli, deniseleliheadpieces.com

SPECIAL THANKS TO STEFAN'S FLORIST IN CEDARHURST, NY

Dedicated to three Js and an M

Table of Contents

Table of Contents

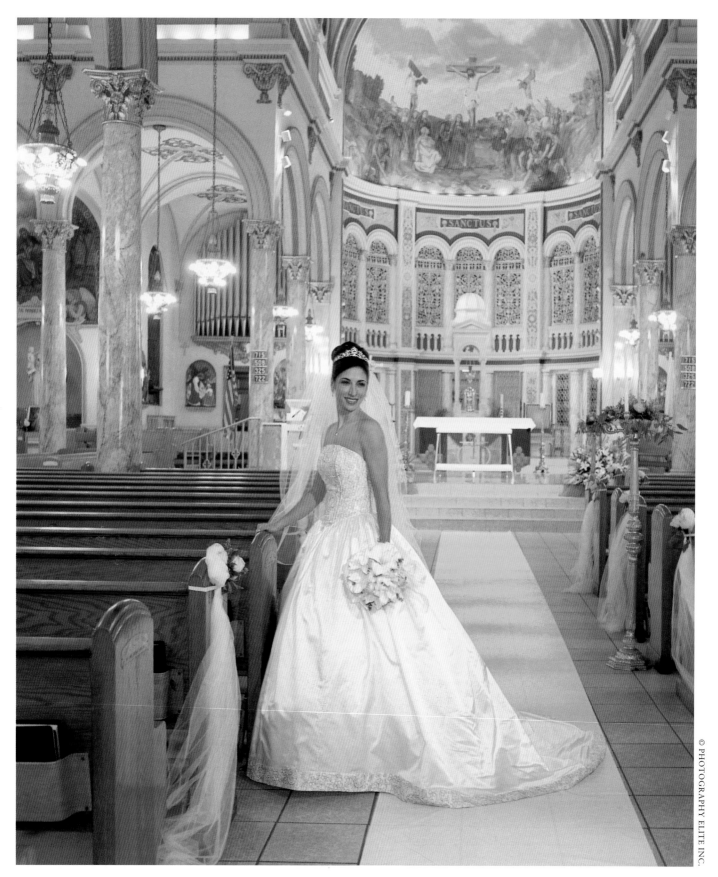

THE BRIDE'S GUIDE TO WEDDING PHOTOGRAPHY

Introduction

He asked, and you said, "Yes!" Or maybe you asked and he said, "Yes!" Whichever way it happened, you are getting married.

First things first—congratulations!

That one fateful word, "yes," now starts a whole process in motion. Family members are notified and friends are told. Co-workers get the news. Telephone lines start singing. It's time for a wedding!

While many of the attendees will only have to polish a pair of shoes or take that special dress out of the closet, you and your fiancé have a lot of work in front of you. You have a wedding day to plan. Not just any day mind you, but one of the biggest days of your life—a day to remember and celebrate for the next 50 years, maybe longer if you're lucky.

During the planning stage you'll meet and interview a host of different people: members of the clergy, coordinators, caterers, printers, bandleaders, florists, photographers, and others. All will be competing for a slice of your wedding-budget pie. Since this book is about wedding photography, I don't want to sound self-serving, but in reality, your choice of photographer is among the most important decisions you'll make.

Almost everything about your wedding day is ephemeral. Invitations, once posted are gone. Cake is eaten, flowers wilt, and bands eventually pack up and go home. After all is said and done, the only wedding professional delivering a product that is designed with the future in mind is your photographer.

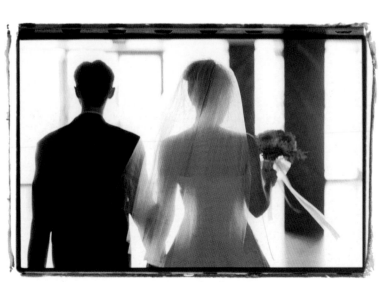

© FRANK ROSENSTEIN

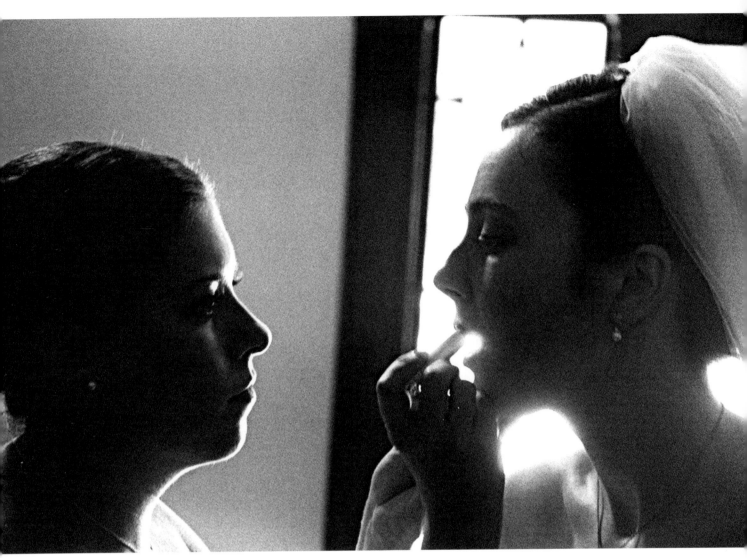

© RICH POMERANTZ

Except for your vows, rings, and photographs, nearly everything about the wedding day is ephemeral. Invitations are sent, food is eaten, flowers wilt, and the band eventually packs up and goes home, leaving only the memories of the day. In many cases even the groom's tuxedo is returned to the rental shop by the next morning. After all is said and done, your set of photographs is one of the few tangible wedding-day products that is designed from the start with the future in mind.

Paradoxically, some inexperienced souls think of photography as unimportant. They misunderstand the very nature of the beast. If you are sitting across the table from your mother, talking over a cup of coffee, it is easy to overlook the benefit a photo of her might hold. You can see her whenever you want. But sadly, that will not always be true. Without being maudlin, the value of owning photographs of Mom depends on whether or not you can be with her anytime you choose. A photograph of a 1-year-old whose face is splattered with strained peas is worth a chuckle when the child is 13 months old. It becomes precious when the child is ten. But, the picture transforms into something priceless when you show it to that child's child.

The day after your wedding, when all the memories of the preceding day are fresh in your mind, photographs of the event have little value. In fact, they can't compare or compete with the carefully edited and stylized view your memory can produce. But on your tenth anniversary, after the passage of time has begun to cloud your memory, photographs are the best way to refresh the feelings that day created.

Given our society's obsession with instant gratification, it is easy to understand why many people take a shortsighted approach to activities that offer rewards down the road, as opposed to ones that furnish a big bang and immediate satisfaction. It is tempting to say, "Forget the photographs, let's get the 10-piece orchestra!" or, "Cut the photo budget and serve the surf and turf."

This is all well and good, but it is also important to remember that after the dust settles, only the photographs are still with you, along with a slight hangover, indigestion, and of course, your betrothed.

OK, you have accepted the premise that photography is important. Now you need to find a way to make smart choices about your photos from both an artistic and budgetary point of view. For starters, this book includes a great deal of the information you'll need. But because photography is a creative field, making intelligent choices requires you to define what is beautiful to you, and what you and your fiancé really want. Much of the knowledge needed to make good choices is already inside you. The trick is to identify and organize this information, and then apply it when choosing a photographer.

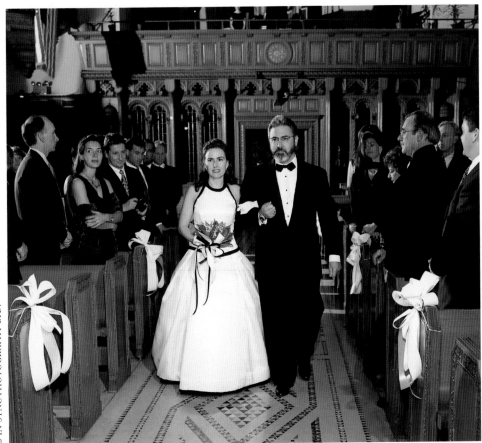

Your photographer will shoot hundreds of photographs because no single picture can say it all about your wedding day. But a photo of you and your dad walking down the aisle will be high on your list of "must-have" shots.

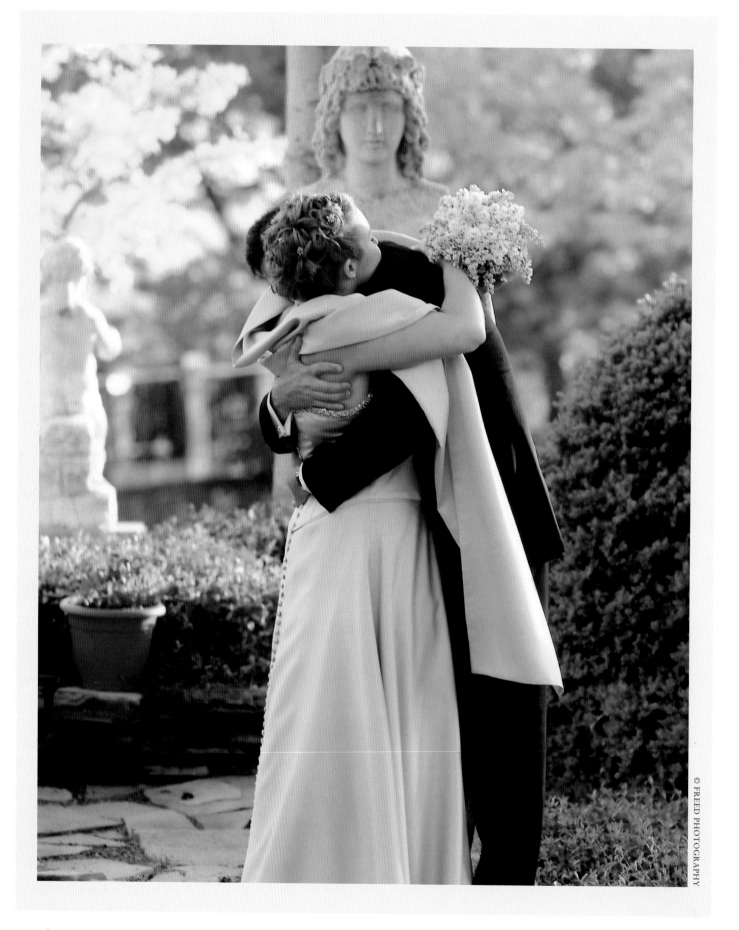

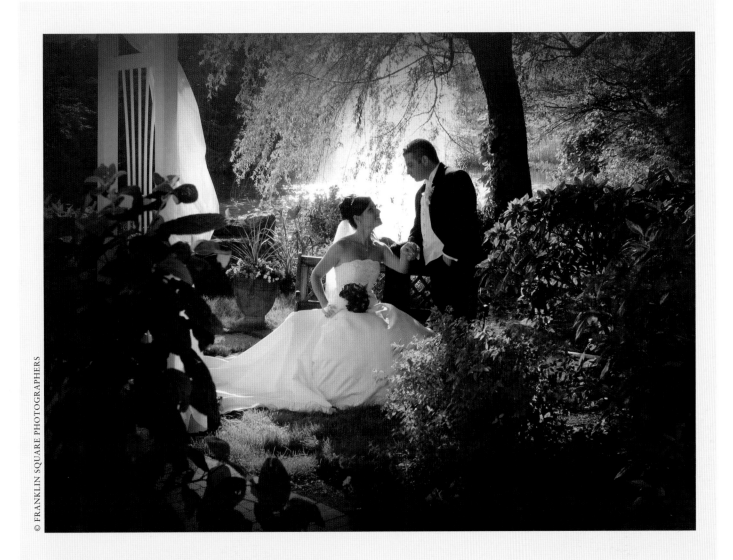

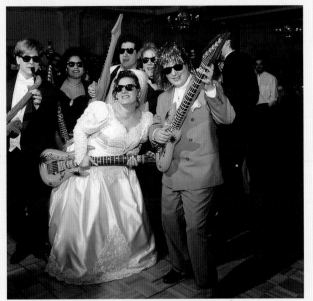

It All Starts With You!

What kind of photographs do you want on your wedding day? I already know the snappy comeback: "Beautiful ones!" Although that is one valid answer, there is much more to it than that. For example, are you a traditionalist, or are you totally freaked by the very term?

Determine Your Personal Style:

1. Will the ceremony be in a traditional church?

2. Will there be a bridal party?

3. Are you wearing a wedding gown with a train? Headpiece? Veil?

4. Do you plan on being walked down the aisle by your Dad, both parents, or are you going alone?

5. How close knit is your family? Do you want a separate photograph with every one of your siblings? Are your grandparents a big part of your life?

© FREED PHOTOGRAPHY

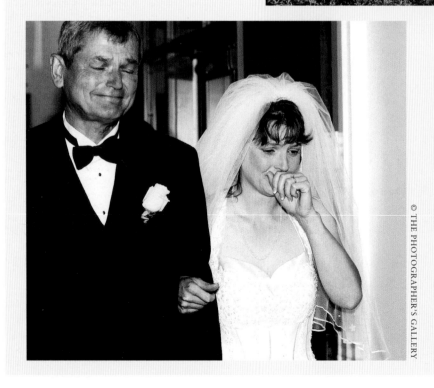

© THE PHOTOGRAPHER'S GALLERY

© MICHAEL ZIDE

THE BRIDE'S GUIDE TO WEDDING PHOTOGRAPHY

© MARK ROMINE

© PHOTOGRAPHY ELITE INC.

© MICHAEL ZIDE

6. Do you plan on arranging the day so that there is a specific time allotted for posed formal portraits?

7. At the reception, do you want the bandleader to announce your grand entrance, the first dance, the toast, and the cake-cutting?

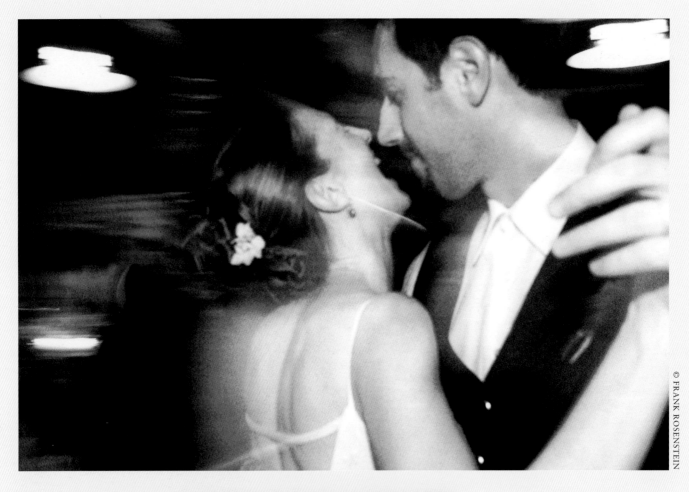

© FRANK ROSENSTEIN

© FREED PHOTOGRAPHY

8. Do you want a special announcement when you dance with your dad or when your husband dances with his mom?

9. Do you want to throw your bouquet? Do you want the groom to toss your garter to the eligible bachelors?

10. Do you want the garter-catcher to put the garter on the bouquet-catcher?

THE BRIDE'S GUIDE TO WEDDING PHOTOGRAPHY

Although some couples revel in the trappings of a traditional wedding, others are aghast at the thought. Relax! There is no right or wrong way to do things. But it is important for you to determine whether you are traditional or more avant-garde in how you look at your wedding day. Once you answer that question, it becomes easy to decide on the photographic style you prefer.

I once shot a wedding for one of America's great families. I charged them a lot of money. I worked all day and into the night, shooting 500 pictures. Within a week I received a check for the entire amount of my contract. But when the proofs were returned, the customer only wanted three 8 x 10-inch portraits. I called to find out what was wrong with the rest of the pictures and was told (by a secretary) that my client loved the pictures but only needed one print for the bride and groom and one print for each set of parents. I had sold three 8 x 10 prints for $1000 each!

Years later, as I toured the estates of America's aristocracy in Newport, Rhode Island, I realized what had happened. For those people with a mansion in New York, a villa on the Riviera, and a horse farm in Kentucky; for those with a second (or third) home on the Seine and a chauffeur on the house staff; for these beautiful people, a wedding is only one more nice day in a life filled with nice days. All the pomp and circumstance surrounding a wedding is just that—pomp and circumstance. But for every one of these people there are millions of others for whom a wedding is a most special event—a once in a lifetime occurrence. To these people, every nuance of the traditional wedding is something to be savored and remembered . . . and photographed.

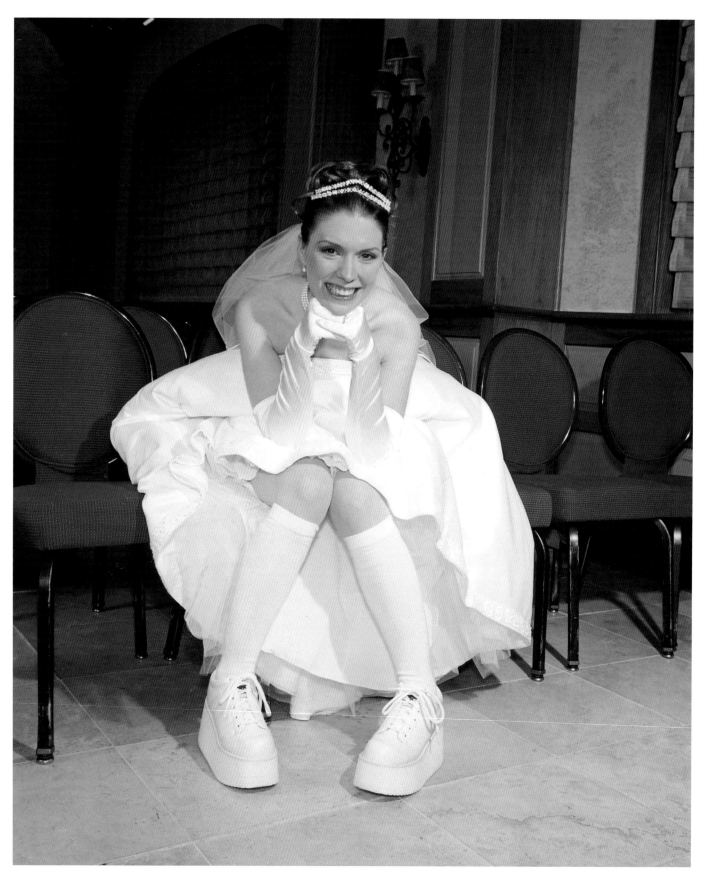

THE BRIDE'S GUIDE TO WEDDING PHOTOGRAPHY

Be the Best You Can Be

There may be an item you wear on your wedding day that has special meaning to you. If so, make sure your photographer captures it. Maybe it's something sentimental like your mom's purse or your grandmother's lace gloves. It could even be something cute or faddishly stylish, like platform sneakers, photos of which can be hilarious when you look at them ten or twenty years down the road. Don't assume your photographer will know that you're wearing knee-highs and platform sneakers if they're hidden under acres of wedding gown!

I am always flattered when someone looks at a photograph I have created and exclaims how lucky I was to be at that place at that exact moment. Luck had nothing to do with it. Superior photos are the result of hard work and planning. When there is excellence behind the camera and excellence in front of the camera, photography can become art. Unlike advertising photography, where the photographer completely controls both sides of the action, your wedding photographer only controls the behind-the-camera part of the artistic partnership. You control what happens in front of the camera. That includes choices you make about your dress, flowers, hair, make-up, picture locations, your bridal party's outfits, and even the way you stand. Your photographer is there to push the shutter button when you are face to face with the flower girl, cupping your hand under her chin, and even though he or she might suggest the pose, in the final analysis, it is you who make the photograph. This chapter will teach you many tricks-of-the-trade so that you can be the best you can be.

Secrets, Read All About Them

There are some tricks you should know that can make you look better in pictures, regardless of whether it's a professional photographer who poses you or it's your uncle whose instruction is limited to "stand over there and smile." For the most part, these secrets about how to pose yourself are optical illusions—usually caused by the fact that the camera is monocular (one-eyed) as opposed to binocular (two-eyed).

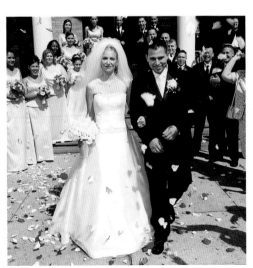
© PHOTOGRAPHY ELITE INC.

The tips are easy and might be likened to the world's most painless diet. If someone were to say that you would look ten pounds thinner simply by standing a certain way, I'm sure you would jump at the chance. By knowing these secrets, and even spending some time in front of a mirror practicing them before the big day, you can help look your best on your wedding day.

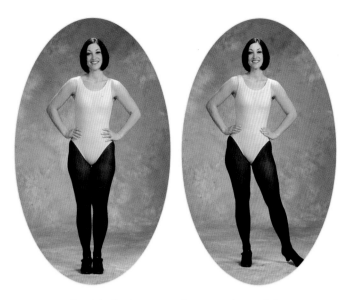

Avoid placing your feet together while flat on the ground (left).

A pointed toe (right) lends more shape to your hips.

Mother Knows Best

Almost every mom has told her daughter to point a toe when posing for a photograph. In fact, there is some truth in this advice. While you may think a pointed toe really doesn't matter because most wedding gowns cover your feet anyway, it does make a difference—but not in a direct way. By moving your foot to point a toe, you are shifting your weight to your back foot, which in turn causes your hips to shift. This hip-shift makes you look more, well—curvy. You want to end up with one of your hips and a buttock to be slightly more pronounced than the other. As with everything, a little goes a long way. So just shift your hips a little. The goal is to look sexy, but with an innocent overtone.

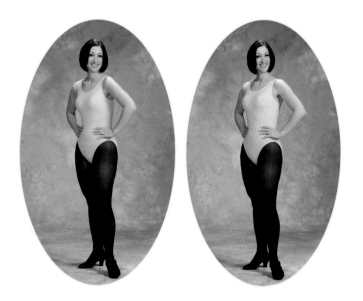

Don't slouch (left).

You look more confident and sure when you stand with good posture (right).

Stand Up Straight

This may seem obvious, but something as ordinary as standing straight can do wonders for your image. Although the groom can also benefit from good posture, it is especially important, and perhaps more difficult, for you. This is because chances are that you have never worn your headpiece and veil for a whole day before. All too often brides look as if they are balancing a bowl of fruit on top of their heads! Don't worry about your headpiece falling off. If it does, there will be plenty of willing hands to help fix it.

Relax Your Shoulders

People have a tendency to tighten and raise their shoulders when they get nervous. This causes a few problems. It makes your shoulders appear narrower than they really are, your neck seems shorter, and most importantly, it creates a feeling and look of tenseness. This is quite subtle, and to resist it you have to concentrate on relaxing your shoulders. Let them fall naturally—getting married doesn't require you to raise your shoulders until they touch your earlobes!

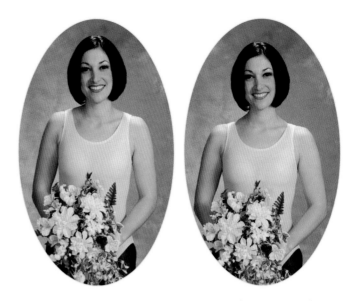

Hunching your shoulders (left) makes your neck look shorter.

When you relax your shoulders (right), you will look more natural and less tense on your wedding day . . .

Position Your Shoulders at a 45°-Angle to the Camera

Because of the camera's monocular view, it is hard to judge depth in a photograph. If you turn your body slightly to the right or left, you can appear thinner in the resulting photo. For example, if you are standing with your shoulders parallel to the camera's film plane, you might be 24 inches wide when measured from shoulder to shoulder. But, if you turn your body to a 45°-angle, the measurement from shoulder to shoulder (in the photo) might be reduced to only 18 inches. In effect, you've traded one dimension for another, in this case trading width for depth. With your shoulders square to the camera your body might only be eight inches deep from breastbone to spine. With your shoulders at a 45°-angle, the depth of your body, which is now measured shoulder to shoulder, is probably 12 to 15 inches. The monocular perspective doesn't reveal two dimensions at once. If only it were so easy to take six inches off your measurements in real life!

. . . and you look thinner when you turn at a 45°-angle.

Get Your Elbows Away From Your Body

If you stand with your elbows touching the sides of your body in a photograph, your body will look as wide as the elbow-to-elbow dimension. On the other hand (or elbow!), if you move your elbows slightly away from your sides, creating a small separation between your body and your arm, people will notice the cut-in of your waistline in your photographs. With your arms out, separate from your body, your torso appears slimmer.

This trick requires care in its use. You want to see a slight separation between your body and elbows. If you move your arms farther away from your body, it doesn't improve the ruse at all. And, pushing your elbows out too far will make you look like you're doing the chicken dance! Also, in the course of moving their elbows outward, many brides lift their shoulders, which we already know is a bad thing. A little separation between elbow and waist is all that's required and all that you want.

Your body appears wider than normal when you hold your arms in, flush to your torso (top).

With your elbows away from your body (bottom), you accentuate the cut-in of your waistline.

Banish Those Double Chins

In an effort to hide a double chin, many people will tilt their head slightly backward. In actuality, this has an adverse effect. It makes your chin more conspicuous, shows off the insides of your nostrils (ugh!), and makes your eyes, the most expressive facial feature, look smaller.

Lifting the chin is the right idea because it stretches the folds under your chin more tightly, helping to eliminate this unwanted feature. However, the foundation for this illusion starts much lower in the body—at your waist.

To reduce the look of double chins, lean forward slightly at the waist and then tilt your head slightly backward. This keeps your face in its normal position. The tilt at the waist cancels the backward tilt of your head, which results with your face being parallel to the camera's film plane. This eliminates the adverse effects of a prominent chin, nostril interiors, or small eyes, which result from just only raising your chin.

Lower Your Chin
to Accentuate Those Eyes

Now that we've taken care of double chins, it's time to accentuate the facial feature that expresses the most about you — your eyes. First, imagine that your face represents a plane. The film in your photographer's camera is also a plane. Now think of both as vertical planes floating in space facing each other. If the two planes are parallel, then the camera will record your face as it exists in reality. But, if you lower your chin by a fraction of an inch, you are tilting your face out of parallel to the film plane, so your eyes are closer to the film than your chin and mouth. This will make your eyes appear larger to the camera. Just a tiny dose of this trick is all you need—so use it sparingly.

Don't pull your head toward your neck while standing straight (left). This will accentuate the lines of a double chin.

Rather, the key is to lean forward at the waist while slightly tilting your head backward (above, right).

It is usually less flattering to lift your head back (left) because your chin becomes more prominent than your eyes.

Instead, lower your chin to tilt your forehead ever so slightly closer to the camera (right). This emphasizes the attractiveness of your eyes.

What About My Eyeglasses?

I've seen brides with a tired eye who don't wear their glasses and then are unhappy with their photos because their eye is wandering in every picture. Other brides go to the trouble and expense of getting contacts, but don't spend enough time getting used to them before the wedding. Their eyes then get bloodshot, or they find both the flash and cigarette-smoke annoying. These brides often end up with a stack of proofs in which they blink most of the time.

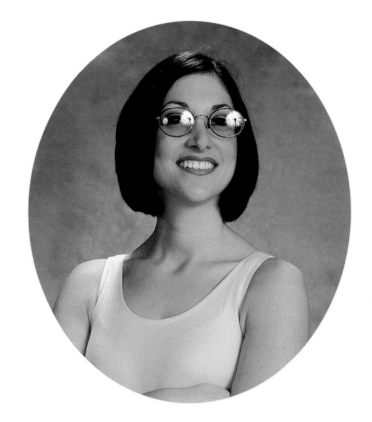

If You or Your Groom Wear Glasses:

1. Photo-gray lenses are a big no-no! They darken when outdoors and you look like a motorcyclist. Even when you are inside, they appear dark in photos.

2. There are non-glare lenses that you can put in your existing frames for relatively little cost. While not 100 percent effective, they help reduce reflections.

3. Have your frames professionally adjusted before the wedding. Make sure the lenses do not tilt upward because this will amplify the reflection from the camera's flash. If possible, the lenses should tilt slightly downward so the flash will be reflected harmlessly towards the ground. This trick can also be accomplished by lowering your chin slightly.

Notice how glare hides your eyes (top).

When wearing glasses, a simple and slight nod downward (bottom) will help cut glare.

Relax Your Forehead

Many times, in an effort to accentuate their eyes, brides will try to open them as widely as possible. You've probably heard someone exclaim a million times (OK, a few times), "Don't squint!" Yet all too often, in the process of "not squinting," people raise their eyebrows, which wrinkles their forehead. While it is important to avoid squinting, you want to avoid raised brows or a furrowed forehead. It often helps to practice your facial poses in front of a mirror. Just go into the bathroom and lock the door so no one will see your antics and think you're a candidate for the funny farm.

Important Words to the Wise

All the suggestions and "secret tricks" about posing should be used sparingly. In every case, overdoing a good thing can result in disaster! Your application of these ideas should be measured in fractions of an inch. As a test case, stand in front of a mirror and look at yourself. Now lower your chin 1/4 of an inch (a measly, tiny distance). Then, try it again, but this time lower your chin a full inch. In the first case you'll hardly notice the difference in the mirror, but in photos, your eyes will look larger. The second instance will result in photos that show double chins galore!

No one trick is going to magically transform you from full-figured bride to svelte super-model. However, by using all of them—each one improving your image a little bit—the end result will add up to a noticeable change for the better in your photographs.

Don't try to open your eyes too wide. This can create unwanted furrows in your forehead (left).

It is better to keep your eyes and forehead relaxed in order to look more natural (right).

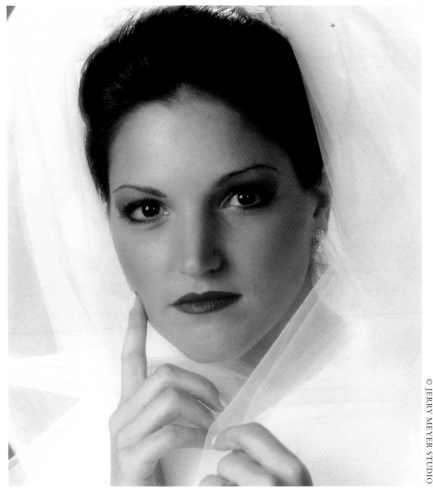

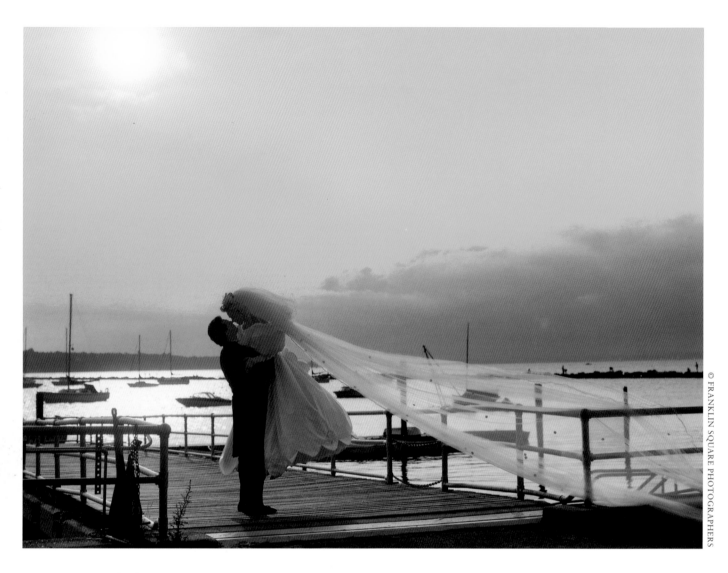

Your Bridal Gown, Train, and Head Piece

As a professional photographer, I can tell you candidly that there are high-maintenance brides and low-maintenance brides. Likewise, there are high-maintenance bridal gowns and low-maintenance bridal gowns. Every competent photographer can find a way to handle almost any type of wedding gown, so your wedding photographs should not dictate what type of wedding gown you choose. At the same time, it is important to at least be aware of the ramifications that a particular style of wedding gown may have on your pictures. You see a photograph of a bridal gown in a magazine or catalog

and you conjure up a fantasy image of yourself in that gown. You fall in love with the dress, the deal is done, and soon the deposit is paid and the die is cast. But, as a photographer who works both sides of the street (magazine-advertising photography and wedding photography), I have some important news to share with you.

Here's the reality. When I create an image for a magazine ad, I often have a whole day to take that one photograph. I may take hundreds of images, each slightly different, but all basically the same. In a

studio fashion shoot there is always a make-up artist and a hairdresser just outside of the camera's field of view, ready to jump in and fix a shiny forehead or an errant lock of hair. Standing right next to these two people is a clothing stylist—steamer at the ready—prepared to turn the slightest wrinkle in the gown into a perfectly smooth, voluptuous fold. The resulting single image is as close to perfection as I can make it, and well it should be, since my goal is to create one perfect fantasy in your mind that makes you say, "I've got to have that gown."

But don't for a minute think that the fantasy I've created has anything to do with the reality of you in that gown on your wedding day. The single advertising photograph you fell in love with is all smoke and mirrors, created in a carefully orchestrated environment with the sole goal of selling you that gown. The model in the ad doesn't have to get in and out of limousines, walk down the aisle, kneel and sit in the church, traipse around the park taking photographs, or dance the night away. She just has to stand still while others adjust her into a frozen state of perfection.

I once shot a lavish wedding with the reception dinner held under a tent set in a back lawn the size of a football field. The lawn ended at the shore of a small, private, man-made lake. From a huge flagstone patio situated at the rear of the palatial home, guests were treated to a scenic overlook spread before them. The bride's gown was beautiful, featuring a tight fitting, simple, satin bodice, ending in a bell-shaped skirt made of layer upon layer of fabric. She was a vision of elegance and perfection in a somewhat aloof and disinterested way. Pity that no one had anticipated thousands (perhaps millions) of gnats and mosquitoes rising from lawn and lake! They imposed themselves between the multiple layers of her dress, dozens in each layer. Although the combined worth of the couple's families could be measured in hundreds of millions of dollars, and the cost of the wedding would be enough for most people to retire on, wealth could not protect her against this assault. By the end of the evening, this bride was absolutely miserable. There is a lesson here.

Although I do not profess to be a fashion consultant, I have shot over 3,500 weddings. I've seen more brides flop and buttons pop than you could ever imagine. In the course of my assignments, I've seen brides who felt both happy and miserable about their dresses. Not surprisingly, most of the problems deal with the train, since no one is accustomed to having a long extension trailing behind them.

Be The Best You Can Be

Drape a long veil over the crook of your arm to keep it from dragging.

© FREED PHOTOGRAPHY

Things to Consider When Choosing Your Gown:

1. If you must have a long train (and they certainly are beautiful), consider falling in love (I know, I know . . . love just happens!) with a dress that has a removable train, not one that must be bustled. Even if you have invented a truly secure method of bustling the train, someone is going to step on it and tear the stays while you are dancing.

 If the only dress that excites you requires a bustle, make a repair kit that you can bring. Include numerous multi-sized safety pins, a spool of thread that matches the dress-color, a few needles, a thimble, a needle-threader (if you need one), and a small scissors. Although this kit can prepare you to for a small tear that could ruin your day, a better alternative is to select a dress with a removable train. And even then, I advise you to bring your repair kit.

2. Many non-removable trains have a loop on the underside that the wearer is supposed to put over her wrist. While the idea is noble, in practice the loops are usually very fine and almost always tear. Have your dressmaker reinforce this loop if your dress has one. Even better, a piece of satin ribbon (matching your dress color) makes a much more substantial wrist loop than the typical spaghetti strap loops. No matter what—bring your repair kit!

3. Avoid walking around on a carpeted floor with your dress and veil dragging behind you. It's amazing how much carpet fuzz the train and veil can pick up due to the static electricity created from dragging. This is especially true in dry winter months. Nothing is as unappealing as a pristine white veil festooned with little maroon, navy, or black balls of catering-hall carpet fuzz.

Your train is supposed to trail behind as you walk down the aisle. For normal activity, however, when the train is not bustled, have an attendant lift the train and drape it over the crook of your arm (this goes for a long veil, too). Hold your arm out straight and start the draping from the front of your body with the end of the train going over your forearm. Once that's done, bend your arm and the train will stay in place without dragging. It's a much better choice than having one (or three) of the bridesmaids holding it while trying to walk behind you. Invariably, you will suddenly stop for some reason; one of your three train-holders will not notice and continue walking, and you can imagine the rest (a train wreck!).

4. When brides with trains back up, there is usually trouble. Never back up in a wedding dress with a train! If you move backwards without first doing something about the train, you are certain to step on your train from the inside and end up performing an inadvertent reverse-somersault.

Whenever wearing a train, think of yourself as one of those delivery trucks that goes, "beep, beep, beep," as a warning before they back up. Instead of stepping backwards, I recommend making broad, sweeping U-turns. If you are in a confined area, turn around by reaching behind and grabbing the train at mid-thigh level with the hand opposite the direction you are turning. For example, if you want to turn to the right, grasp the train with your left hand and pull it around with you during the turn.

I can say from personal experience (as the photographer) that falling down in a wedding dress is no fun—although it might be perfect for "America's Funniest Home Videos." Once again, be sure to have your repair kit available in the car or someone's purse.

5. If you must have a cathedral-length veil (one that is longer than the train), make sure it is easily removable from the headpiece. I have seen many long veils that attach to the crown with a strip of Velcro. True, a long veil is a sight to behold as you walk down the aisle, but when it wraps around you as you twirl on the dance floor, it is also a sight to behold, only in a different way.

6. Many brides love the look of a mantilla headpiece with its beautiful lace edges framing their faces. Sure, this style always looks magnificent in the advertisement (that "perfect" photograph is selected from hundreds shot in a studio). But remember that in real-life, halfway through the wedding day, you'll be constantly flipping the darn thing over your shoulders to get it off your face.

If you have positively fallen in love with a mantilla and cannot do without it, try to get one that is attached on a head-cap so you can place the cap towards the rear of your head. That way, when you decide to flip the lace over your shoulders to clear your face (and you will want to do that on a hot day), the mantilla's edges will stay where you've placed them.

Hair and Make-up

Beware! Your wedding day is not the time to experiment with a new make-up design or hairstyle. You are going to have photographs taken that will, hopefully, be appreciated for the next 50-plus years! Your wedding pictures are too important to gamble on. It's not that you shouldn't do something special with your hair and make-up. Perhaps you simply want to accentuate the current styles you like to use when you want to look your best.

In any case, you must do a trial run before the actual day. Whether the person doing your hair and make-up is a professional, relative, or a close friend, you definitely have to try it all out before the big day,

including the headpiece as well as your hair and make-up. It may be that your headpiece requires you to wear your hair up, not down, on your wedding day. Or perhaps you only wear a touch of make-up on a day-to-day basis, but on your wedding day you want to do something really special. Regardless, the very fact that you are inexperienced with the outcome of this new look makes it important that you do more than just hope it will come out perfectly.

Creating great make-up and hair is a subtle thing, and therefore it deserves your attention beforehand. Since you will rehearse the other parts of the wedding to get them just right, why not try a dress rehearsal with your hair and make-up too?

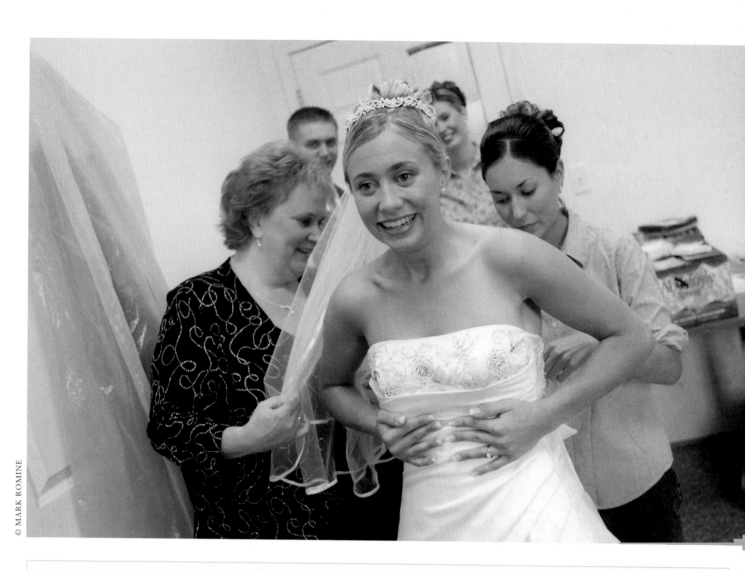

Suggestions For a Trial Run:

1. To insure your hair looks good, ask your dressmaker to finish your headpiece long before you go for the final fitting of your gown. Do your hair as if it were your wedding day, and put on the headpiece. You need to know that your crown and hairstyle work together, and it's a good idea to know how the headpiece will attach too. Whoever is going to help you put the headpiece on before your wedding should also be there during the trial run.

2. For make-up, consider taking notes on which colors are being used for lipstick, blush, and eyes. Remember, there is always a difference between how something looks in a mirror and in a photograph. So, ask your photographer if he or she can take some test shots of your new look. Even if there is a nominal extra charge involved, it will be worth it—you are only going to get one chance to shoot your wedding photographs.

Bouquets

There are three basic types of bouquets: arm, cascade, and snowball.

The arm bouquet is made from long-stem flowers and doesn't have a handle in the traditional sense. It most often looks best running along one of your forearms with the blossoms nestled into the crook of your arm. You can place your free hand on your waist or wrap your fingers (with your hand palm-down) around the lower part of the stems.

© MARK ROMINE

Hints for the Arm Bouquet:

1. Never cup your second hand under the end of the stems. It appears uncomfortable and your hand will look like a closed fist!

2. You should flip the bouquet to either arm depending upon how you are standing (remember the 45 degree turn rule) so that the blossoms and not the stem-ends are more prominent. Think of this as a floral flip!

3. Never hold an arm bouquet in two hands with the stems vertical. It looks as if you are lying in state!

Snowball and cascade bouquets are similar, but the snowball is round while the cascade is elongated with the flowers flowing out and down. Both have a handle. As with the arm bouquet, you should never cup your free hand under the base of the handle. Instead, keep your wrists near your hips, with the rear hand holding the handle and the other hand palm-up, supporting the blossoms. This creates a pleasing look.

One last hint! When holding either a snowball or cascade bouquet, you should not be able to see the top of it when you look down. This means the camera's lens is seeing a vertical view of the bouquet, exposing the handle and your hands instead of just the blossoms. Tilt the bouquet slightly forward, toward the camera. You should now see a bit of your hands and the handle next to your belly when you look down, while the camera sees the floral portion of the bouquet rather than the handle.

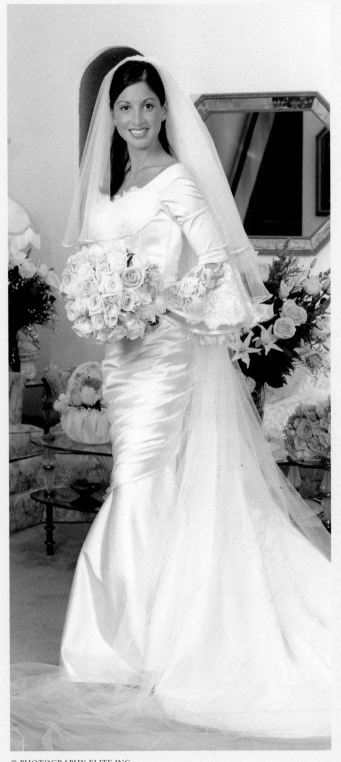

© PHOTOGRAPHY ELITE INC.

Once you have determined the type of bouquet you want for your wedding, I advise you to stand in front of a mirror and practice holding your flowers.

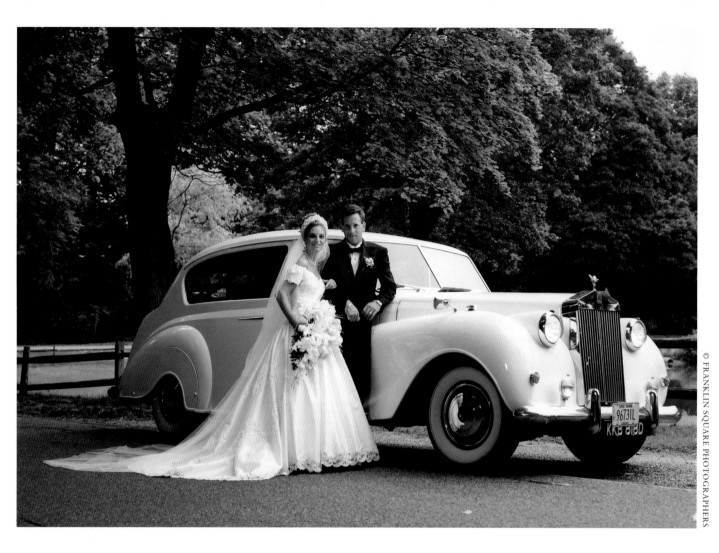

Some Thoughts About Your Flowers

More times than I care to remember I've seen two-foot, cascade bouquets on brides less than five-feet tall. Conversely, I've often noticed small, snowball bouquets carried by statuesque, six-foot brides. Whichever bouquet style you decide upon, it is important to remember that your physical stature often indicates which size fits you best. Regardless of what I suggest, it's your day! If your heart is set on a specific bouquet, then that is the right one for you.

There is one special trick that I have not yet mentioned that is important when dealing with flowers. Whatever bouquet you choose, the question,

"How should I hold my bouquet?" can be answered with just two words: "Lower it!"

Many times brides look as if they're hiding behind their flowers. Here's the scoop. The bodice of your wedding gown is beautiful, so why hide it behind your flowers? Don't hold your bouquet too high because it will also hide your bust line. A high location also places your forearms in a horizontal position, creating a line that cuts your body in half. Almost everyone with a bit of fashion sense knows that wearing horizontal stripes makes you look wider, and horizontal forearms do the same thing.

By holding the bouquet lower, some brides can cover a little potbelly or broad hips. As an added advantage, dropping the flowers a bit places your forearms at a 45-degree angle, which makes your body look longer and leaner. If you are unsure how low to hold your flowers, here's a little trick—if you let your wrists rest on your hipbones, usually, you've hit the perfect height.

Don't hide yourself or your dress behind your flowers (top, right).

Do hold your bouquet low, with your wrists on your hipbones (below).

© FRANKLIN SQUARE PHOTOGRAPHERS

It's Going to Be a L–o–o–o–o–n–g Day

Consider gardenias. They are one of my favorite flowers. First of all, they are beautiful. As an added benefit, their fragrance is so intense and intoxicating that, once you experience it, you always remember the aroma. But sadly, they are also very fragile. Just touch a gardenia petal and 20 minutes later there will be a brownish stain on the spot where your fingertip grazed it. Their fragility makes them a poor choice for a bridal bouquet. Flowers in a bridal bouquet should be hardy, because you and your bouquet are in for a long day.

It is common for a dinner reception to begin four or more hours after the start of the wedding ceremony. And your bouquet will be on duty for a much longer time. Even if the church is just two minutes from your home, remember that many photographers like to have a one-hour photo session at the bride's house before the ceremony. The florist needs to deliver your bouquet at least an hour before the photo session. Yet on a Saturday in prime wedding season (May through October), the florist may be extremely busy, and your bouquet might arrive even earlier in the day because the florist can't time everyone's delivery perfectly. Most likely your bouquet will start to fade well before the end of the day.

But let's think positively and assume that all the bouquets and boutonnieres arrive at your home exactly on time — saints be praised! Even if you keep your bouquet fresh in the refrigerator until your starting time, it still has to weather the photo session. Then it will be shoved into the car with you for the trip to the church, where it is likely to sit on the altar during the ceremony for an hour or more. Someone will then hold your flowers during the half-hour receiving line after the ceremony. Next, it will accompany you and your shiny new husband back into the car for another drive and photo session at a park or similar locale, only to be piled back into the car for a third trip, this time to the reception hall. Finally, thirsty and wilting, it will sit forlornly on the head- or cake-table as it awaits its final trip — a short flash-lit flight into a throng of crazed girls at the evening's end. Whew! Since you hope your bouquet looks as fresh at the day's end as it did at the day's beginning, you are asking a lot from a bunch of cut flowers held together with a bit of tape. Do you wonder why it is best to choose hardy flowers for your bouquet?

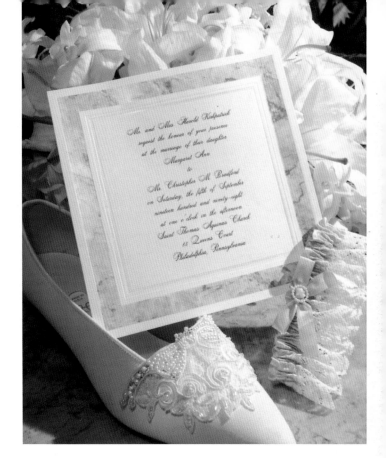

Give Your Photographer Some Extra Help

One simple and inexpensive thing to add to your floral order is a single rose. Your photographer can use it as an additional prop to add variety to your portraits. It also works very well for close-up photos of your face. If you are in a particularly festive mood, you can even grab it in your teeth and pose yourself like a flamenco dancer.

A single rose can add a nice touch to portraits

Another useful prop is a copy of your wedding invitation. A simple photo of it propped against your bouquet, maybe with your garter draped over a corner of it, can be a great starting photo for your album. Suggest that the photographer carry the invitation with him or her after taking the photo. This way he has the wedding location with him if he gets separated from the limousine. And, since it's such a great leadoff album-photo, it might be used in a second picture—propped against the cake or a couple of champagne flutes.

© FRANKLIN SQUARE PHOTOGRAPHERS

A Note for Romantics

As a child, I once came across a dried flower pressed between the pages of a big book on a shelf in my parents' library. I asked my mother what it was, and she told me it was a flower from her wedding bouquet. I have always remembered that flower. Some brides are so sentimental that they instruct their florist to make an extra mini-bouquet that they can throw, saving their original bridal bouquet for the future. Here's another solution: before tossing your bouquet, pull out a flower or two to save and press. It will be a nice memento in a few years.

The Artificial Alternative:

With advances in their quality, artificial flowers have become an interesting alternative to a live-flower bouquet. Without the slightest doubt, there is no way an artificial bouquet is as elegant as a real one. But, consider these advantages before you wrinkle your nose and say, "Yeech!"

1. An artificial bouquet does not wither and droop as the length and heat of the day increases.

2. An artificial bouquet is much lighter than a live bouquet.

3. Live bouquets are often made by pushing the flowers into a block of special Styrofoam that is first soaked in water. But a damp bouquet and a satin bridal gown rarely mix well. Furthermore, with a live bouquet, flowers will be falling out of the Styrofoam block soon, while an artificial bouquet can be more sturdily constructed.

4. An artificial bouquet lasts forever, so you can keep it as a memento.

5. An artificial bouquet can be ready days before the wedding, so you can approve it and have time to change it if need be. You can also see how it looks with your headpiece and make-up when you hold your preliminary "trial run."

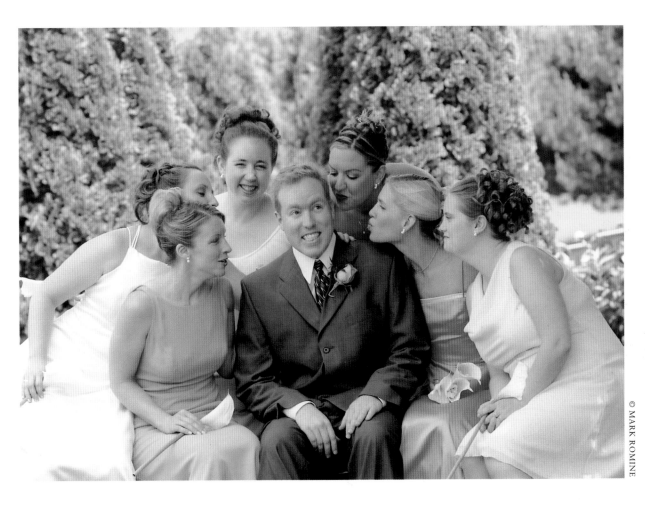

Some Thoughts for Your Future Husband

When it comes to formal attire, grooms often require a reality check. Let's face it, many guys don't care about their appearance as much as you care about yours. Left to their own devices, many guys would choose jeans or khakis over a formal suit or tuxedo. Some guys just need a bit of help with formal attire. After all, as the popular book title tells us, "Men Are From Mars, Women Are From Venus." It has been said that a wedding is the bride's day and the groom goes along for the ride. I believe this to be partially true, and I also believe that he might roll his eyes occasionally when you make suggestions or try to involve him in planning the minutiae that you find so important. Don't feel let down. You're interested in the perfect wedding (and perfect wedding photos) but almost better yet, he's only really interested in you!

Here's a secret: no matter how interested your groom professes to be in your wedding plans, the typical male often doesn't care if there is black, mauve, or green table linen. And, many grooms often just like cake regardless if it is German chocolate or whether it has nuts or strawberries. Do not let this frustrate you. Knowing and accepting this can help you to help him. After reading this book, you will suggest some ideas that will probably embarrass or make him uncomfortable. But a marriage is a joining of two people, where one partner's limitations can be "covered" by the strengths of the other.

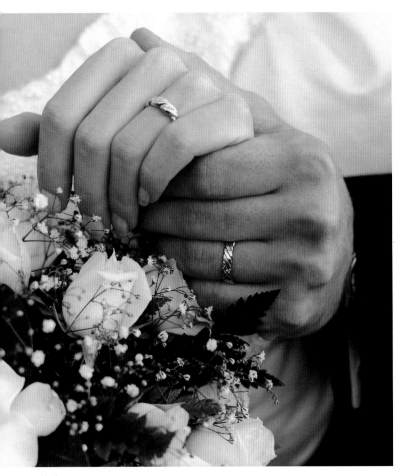

Two people with well-manicured hands create photo opportunities beyond the typical "ring shot."

For Both of You: Get a Manicure

There is nothing that can ruin a close-up of a couple's hands sporting shiny, new wedding rings more than dirty fingernails and chewed up cuticles. Likewise, a groom lifting his bride's chin with his fingertip in preparation to kiss her is the type of photograph you see on greeting cards, but it can quickly lose its appeal if his (or your) fingernails are unkempt.

A manicure can cure all this. The problem is that many guys think a manicure is a woman's thing. Explain that he might even enjoy this new experience. If a coat of clear nail polish sounds too feminine to him, suggest just having his fingernails buffed. Remember, your goal is that great shot of your rings.

Oh, and one last thing. If you or your fiancé bite your nails or cuticles . . . stop!

If it's you, stop four weeks before the wedding. Then, two weeks before the wedding get yourself a manicure as a reward. Once you see how nice your hands look, the last two weeks will be easier. A few days before the wedding you can get a second, final manicure.

Go With Him to the Tux Shop

Some guys actually think there is nothing wrong with wearing a paisley shirt, striped pants, plaid jacket, and bright red socks—at the same time! They might even think this "look" is stylish! To many men, "color sense" means that everything falls into just two categories: colored or black-and-white. If your fiancé is going to rent or buy a tux for the big day, ask if you can tag along. When he puts on an outfit that you like, tell him how cool he looks. Because some guys are at a loss when it comes to choosing formal attire, he probably will welcome your help.

If your groom is going to wear a suit rather than a tux for the wedding, offer to help him pick out an appropriate tie, and gently remind him that his shoes should be more formal than red sneakers.

Pinning On a Boutonniere

Boutonnieres for the men in the wedding party are delivered to the church with the altar baskets on the big day. Here's the story: The guys open the box, look at the flowers and pins, and become helpless. Hopefully the priest, minister, rabbi, or groom's mom will be there to lend a hand. Otherwise the guys, left to their own devices, will stick the pins through the flowers and then jab them into their chests, drawing blood while treating the whole process as some mysterious rite of passage.

Here's the inside info on how to pin a boutonniere. After you read this, get a flower and a pin and show your groom how it's done. It's really quite simple. Have him take off the jacket and practice until he can pin it on the lapel by himself. Then, on the wedding day, he'll know how to do it and can be a showoff to his friends as he helps them get their boutonniere act together.

Boutonnieres go on the left lapel. With a little practice, they are relatively simple to pin on attendants and ring bearers.

Boutonnieres always go on the left lapel of a jacket. Hold it in position with the pointer-finger of your left hand. Correct placement is usually towards the top of the lapel. However, if there is a sewn-shut buttonhole on the left lapel, make sure the blossom of the boutonniere hides it. While keeping the flower in place with your left pointer, use the thumb of your left hand to turn the lapel over. Using your right hand, starting at the inside edge of the back of the lapel, with the pinpoint aimed toward the outside edge of the wearer's body, push the pin through the lapel so the point is sticking through the front. The shaft of the pin should be almost parallel to the lapel. Then, push the pin through the stem of the flower and back through lapel. When you turn the lapel back over, so the outside is facing you, the pinhead and point will be hidden behind the lapel. That's it, you're done! Easy!

THE BRIDE'S GUIDE TO WEDDING PHOTOGRAPHY

It Is Your Wedding

It is important to remember that everything described here is centered on a traditional wedding. If your idea is to wear a white (or even bright red!) peasant dress, then by all means, do so. If you, and your groom, think it would be fun for him to wear a football jersey or a cheese-head hat, then by all means do that too. It is your wedding. However, remember that most people regard a wedding to be a solemn ceremony, steeped in traditions that represent the importance of the commitments involved. It's hard to know how to follow a tradition if you've never done it before, so the purpose of this book is to help you in this area. But, in the end, it's your wedding, your memories, and your photographs. The point is to have a great time and do it your way.

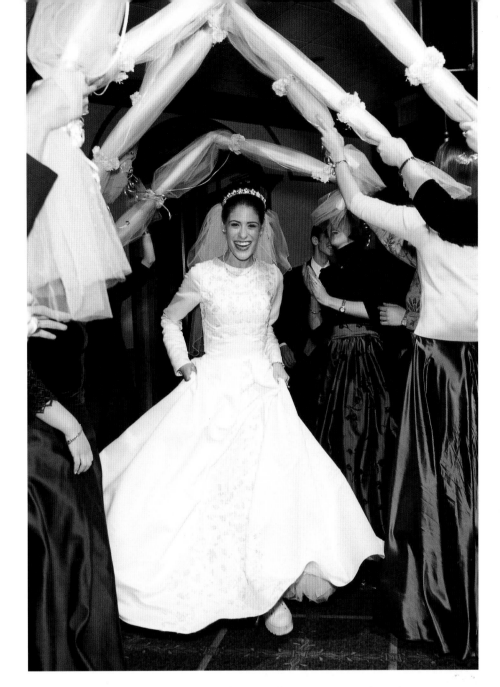

Remember that your photographer is not a mind reader. One way to insure that you get photos of important traditions is to tell him or her ahead of time about the specific activities that you want photographed. Some things are easy to catch, such as the fireman-groom stopping at the engine-house with his new bride for a photo on old Engine Number 7. But other customs, such as your friends forming an arch for you to run through on the dance floor, can happen and be over in an instant.

If certain religious observances or particular ethnic traditions will be celebrated at your wedding, you might consider finding a photographer who is familiar with these customs.

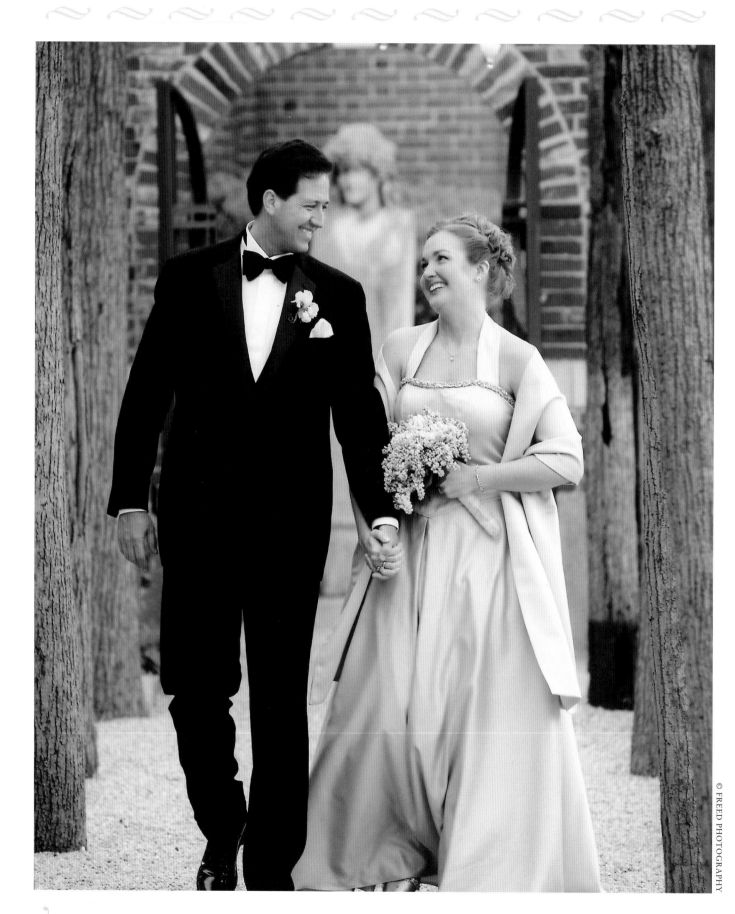

How Much Does It Cost?

Take a Deep Breath . . .
There can be Pictures for Every Budget

In the United States there are approximately two and a half million weddings every year, and they cover a broad range of sizes, styles, and budgets. There are couples who get married at city hall with just two friends as witnesses, and there are brides who plan their wedding for years with the goal of creating a lavish banquet for hundreds of guests. My dilemma is how to offer germane advice to brides with photo budgets ranging from $20 to $20,000. But don't worry. There are solutions for all types of photographic preferences and costs.

Whether your ceremony is performed by a judge in a courthouse or by a cardinal in a huge cathedral, you will want pictures to preserve the special moments of your wedding day.

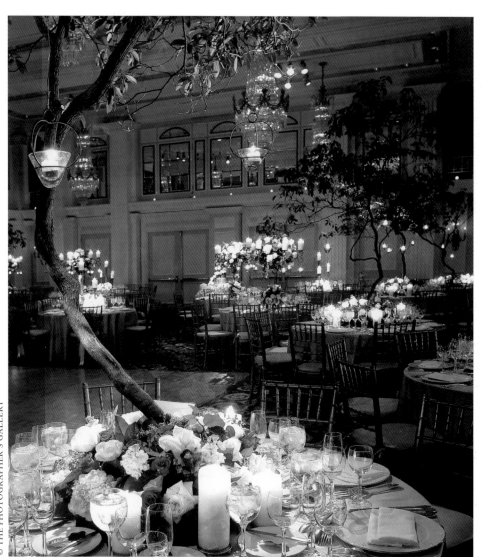

© THE PHOTOGRAPHER'S GALLERY

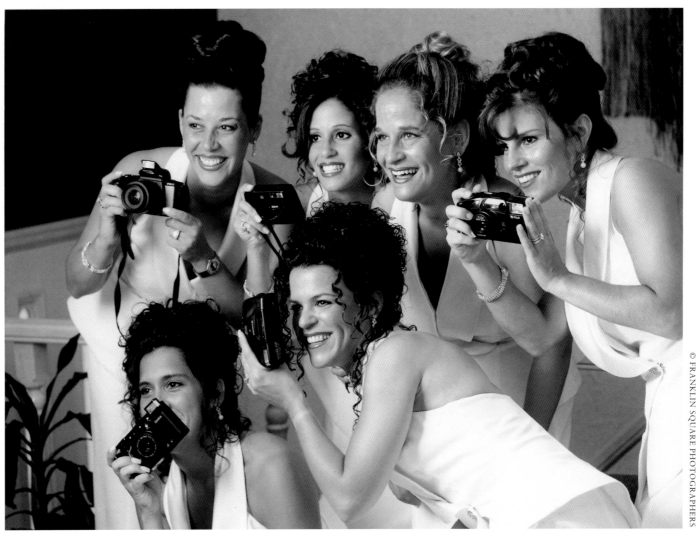

The Minimalist Set of Wedding Photos: Less Than $30!

Even if your entire list of wedding attendees consists of just you, your fiancé, and your two best friends acting as witnesses, you should still record this special day on film. A minimalist wedding does not mean minimalist love. You will both be glad in a few years that you had pictures taken on the day that changed your lives forever.

If you are on a tight budget, a single-use camera can be bought for less than $10, and the prints will cost another $10. You can take one step up if a friend has a 35mm camera you can borrow. A roll of film can be purchased for approximately five dollars, and a set of prints can be produced for between $10 and $20. Some photofinishers will even throw in a second set of prints for that price.

It has often been said among photographers that it's not the camera that makes a great photograph, but the photographer behind it. I agree.

How to Get Good Pictures on a Budget:

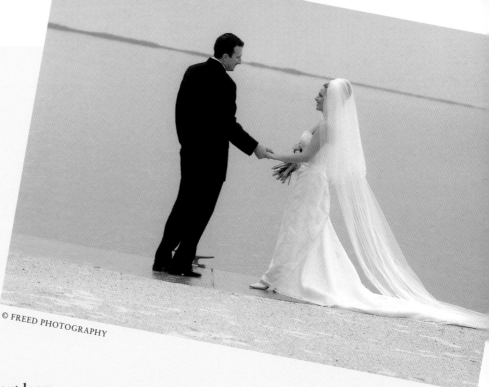

© FREED PHOTOGRAPHY

1. Study the chapter in this book called "Be the Best You Can Be."

2. Take a few seconds to check your make-up, straighten your hair and his tie, button his jacket, and check your smiles.

3. Pick a nice, simple background, outdoors if possible. Let's hope it's a sunny day.

4. Even an inexpensive, single-use camera can take great photos if you work within its limitations. Most of the photos should be taken from distances of six to twelve feet.

5. One or two people who are standing comprise a vertical subject. Be sure to turn the camera sideways so it takes a vertical-format photo as opposed to a horizontal one.

6. Try to get some variety in the photos. Plan your pictures to cover all the possibilities on your one roll of film. Make a short list for the photographer so that he or she is sure to take pictures of:
 - Yourself alone—full length and close-up (three of each)
 - Your groom alone—full length and close-up (three of each)
 - The two of you together—full length and close-up (four of each.)

Try to change the background by moving to another spot during the "photo shoot," so if one location doesn't work, you'll have a backup.

7. This simplified list comes to twenty pictures— for the rest, get creative. Use your imagination! Maybe two or three photos of you and your groom with the witnesses (a group of four people close-up fits best into a horizontal format). Ask a passer-by, or even the Justice of the Peace, to take these for you. If your camera has a flash, try a few photos of you two at dinner, or looking out of the car window. Maybe include a photo of the church from far away, or of city hall with you and your husband on the steps. You never know, your marriage might outlast the building!

Remember to plan a list of shots with a variety of subjects, poses, and scenes. Have fun and be creative. This type of photo shoot is short and sweet, so relax and enjoy it.

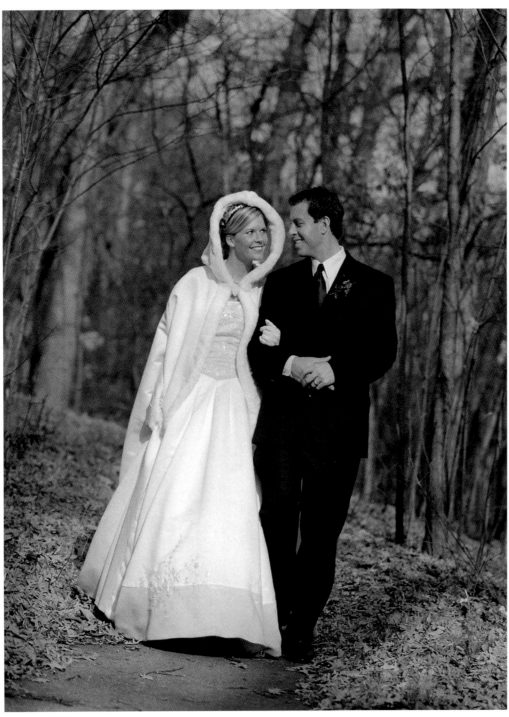

© MARK ROMINE

The Small Wedding: Less than $300

It is possible to get a nice set of wedding photographs without hiring a professional photographer. This sleight of hand is achieved by asking a relative or friend to take your photos for you. While this creates considerable savings, there are also many downsides that should be considered. We all know someone who enjoys photography—an uncle, aunt, cousin, or friend. Often this person will be pleased to play wedding photographer.

When a Friend or Relative Takes Your Photos, Avoid These Common Pitfalls:

1. Five, ten, or more rolls of film and processing at almost $25 dollars each can add up quickly. This is a big gift to expect from someone who is also donating his or her time. Insist on paying for the film and developing expenses. Ask what size, type, and brand of film, along with how many rolls the photographer wants, then buy the film. I recommend that you buy more than they request. And, don't take no for an answer. Trust me—they'll appreciate your gesture.

2. Understand that the role of wedding photographer is a big responsibility. Try to enlist someone who won't be tempted to join the celebration and start partying.

3. You know you want shots of you along with your groom and attendants, but come up with a short list of other important photos you'd like your photographer to get. I emphasize "short," so it's not an undue burden on your "volunteer." It is also helpful if the person knows or is aware of the special people at your wedding so they won't miss that photo of your favorite niece.

4. Remember that your photographic volunteer is giving up partying to take your photos, so be sure to express your appreciation.

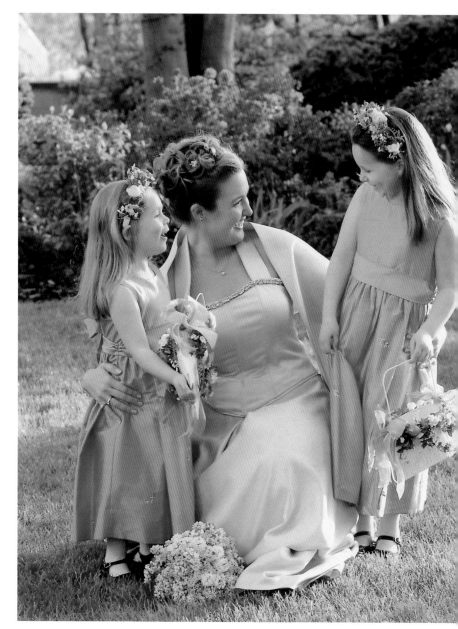

© FREED PHOTOGRAPHY

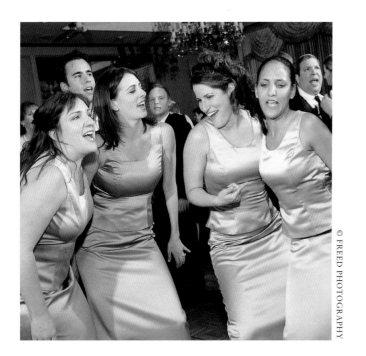

Portraits are nice, but there's something special about the spontaneous moments when you and your friends let your hair down.

© FREED PHOTOGRAPHY

Single-Use Cameras—Not a Great Idea

I have seen some couples purchase a bunch of single-use cameras and place them on the tables at their wedding reception, assuming that the guests will use them and take meaningful photographs. In my experience, this never works as planned. More often the result is a comedy of photo bloopers. Here are some results that I have witnessed from this practice:

• A gregarious fellow picks up the camera and shoots the whole roll of photographs of his girlfriend (whom you might not even know).

• A tipsy guest shoots an entire roll of his feet, or worse still, his nose, because he is looking through the wrong side of the camera's viewfinder!

• Someone gives a camera to a little kid, who, filled with exuberance, runs around snapping photos of everybody. However, because the child is only three feet, six inches tall, all the photos are from belly-button height and every subject's head is cut off.

I have actually seen all of these happen—more than once. Most of the photos produced this way are destined for the trash basket. So, in addition to spending all that money on the cameras, you may also be irritated when you pay for the processing of all the worthless photos! The cost of buying twenty cameras ($200) and paying for film processing ($300) starts to add-up quickly.

Remember these words: It is the wise bride indeed who doesn't pin all her hopes for great wedding pictures on inebriated guests using single-use cameras!

What About Digital?

Because there are no film or traditional processing costs, digital photography might seem like a perfect solution to your tight budget. As a professional photographer, I have used digital photography exclusively for magazine assignments, and I embrace the advantages of this format. However, there are tradeoffs between traditional film and digital files that are important to wedding photography.

© FREED PHOTOGRAPHY

In addition to a digital camera, which is currently more costly than an equivalent film camera, you will need access to a computer to view your digital photographs. While you can have prints made from the digital format, these prints are usually more costly than traditional prints. Consequently the savings created by eliminating film are reduced. Since low-priced digital cameras have low resolution, your photos will look fine on a computer screen but may not print satisfactorily. To compound this problem, if the camera doesn't have extra memory cards with it, you might be tempted to lower the resolution of the camera's photographs, which will only exacerbate the print quality problem.

At this time, although the savings over film and processing are considerable, the cost of the complete digital photography experience may not be as inexpensive as you expect. Even if the person who is taking your pictures is an avid digital photography hobbyist, my advice is that you urge him or her to shoot most of your wedding photos with a traditional camera. If you want digital files, your photofinisher can digitize the film, or the pictures can always be scanned. But if you want big enlargements or a lot of reprints, you will have better options with film.

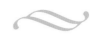

Hire a Student: Stepping Up to the $500 Range

If your photography budget is tight but has room for more than just the cost of film and processing, you can relieve your uncle or friend by hiring a student. However, this may require a little legwork and creativity on your part.

Nearly all schools—high schools, trade schools, junior colleges, colleges, and universities—have photography classes or clubs, and some even have photography departments. There may well be a great photography student who would just love to make a couple of hundred dollars photographing your wedding. Call the school's guidance or photography department (ask for the department chairperson, class teacher, or advisor of the photography club). If the school doesn't have a photography club, they often have students who photograph for the yearbook. These students are probably a good choice because they are experienced at taking pictures of people and events. Contact the appropriate faculty member and ask for recommendations.

Then get in touch with the students and tell them what you are looking for. Meet with likely prospects and ask to see a portfolio of their work. At the

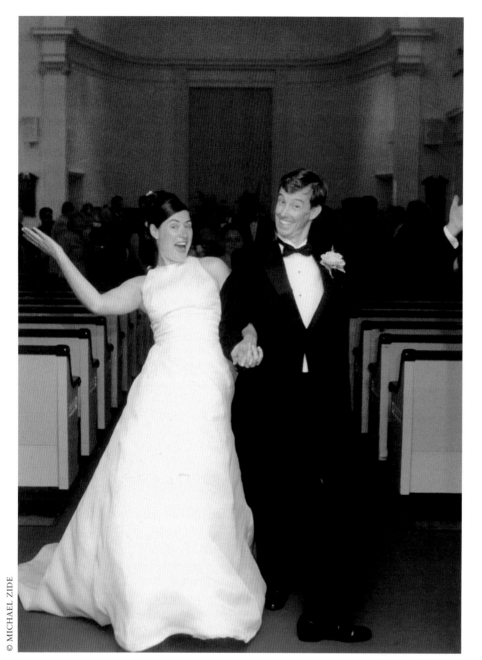

*If you and your husband
plan a special moment together,
make sure to let your
photographer in on
the surprise so he can capture
the action.*

meeting, be prepared with a list of the photos you will want and explain that you will pay between $15 and $35 per hour depending on experience, and you will also cover the cost of film and photo-finishing. Or you might settle on a full day rate of up to $250.

If the student is interested, write down the agreement that you've made and have the student sign it. Make sure this document includes the date of the party, the location of the wedding and reception, the time of the ceremony, how much you are paying per hour (or per day), and most importantly, that the film and resulting negatives belong to you. Prepare two copies and give one to the photographer while keeping the other for yourself.

During the interview with the prospective photographer, examine their portfolio carefully. Under-stand that, while students can often be very creative, you want what professional photographers call "bread and butter" photography. While a single image of you and your fiancé swinging from a chandelier might be a lot of fun, what you need most is clean, straight portraits and pictures that illustrate the important events of your wedding day.

Check out more than just the student's portfolio. Consider also: personality, a willing smile, a neat appearance, and a conscientious attitude.

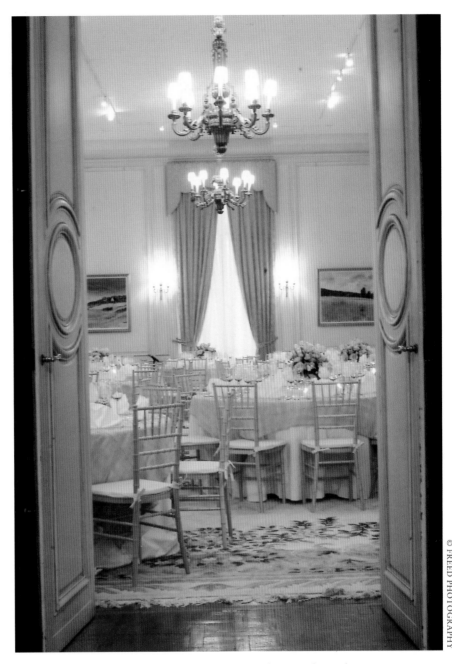

© FREED PHOTOGRAPHY

With everything that is going on, you may miss many of the fine details of your wedding day, such as the beautifully decorated dining room. That's why pictures are nice—ask your photographer to take a shot of the room for you.

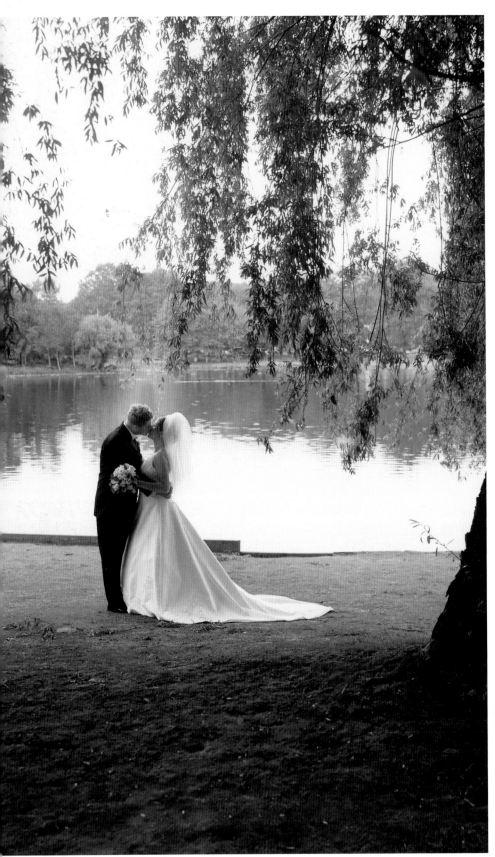

© PHOTOGRAPHY ELITE INC.

Consider This

Whenever you use an amateur photographer (friend, uncle, hobbyist, or student), it is unlikely they will have the experience that a professional possesses. A helpful gift in this case would be a copy of my book, *Wedding Photography: Art, Business, and Style, Second Edition*. Among other things, it includes an annotated version of the Repertoire chapter found in this book (page 67), plus tips on how to get things done quickly and efficiently. I know it will add to the knowledge base of any neophyte wedding photographer.

The truth is, great photography often happens because the photographer has "been there, done that." He consequently knows where to be and when to be there. For example, your uncle who is taking pictures might be engrossed in a conversation with a guest, while the bride and groom are cutting the cake. Or he may be eating his cake while the bride is tossing her bouquet. The inexperienced novice cannot anticipate a series of events, while a pro can stay one step ahead of the action. The safest way to insure that you will be totally satisfied with your wedding photos is to hire a professional.

The Photos Themselves

The costs discussed to this point have only covered film and processing, plus wages for student photographers. You will likely want to buy reprints and enlargements, also.

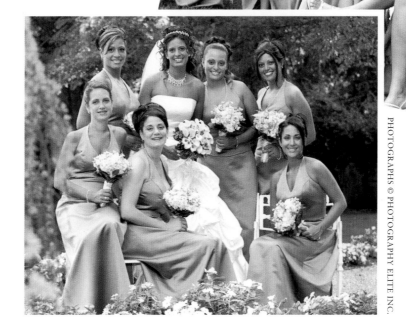

Since 35mm film is used in all of these plans, you will generally receive standard 4 x 6-inch machine prints from your photofinisher. You can make enlargements of favorite photos at any time as long as you take good care of your wedding negatives.

Traditional wisdom calls for dark, cool, dry storage to best preserve negatives. Photo stores sell clear-plastic archival pages for storing negatives. Most of these page-systems fit in a standard ring binder and are worth the small investment.

Don't forget about the wedding album! If your budget is very tight, your immediate concern should be getting the film shot and the negatives processed. Your wedding album can be made at a later date. Consider saving mementos that you might want to add to the album later—a copy of the invitation, a pressed flower from your bouquet. However, be sure to store the flower somewhere other than with your photos because it can damage the pictures.

Until you have time to put your album together, you should also store your pictures in a safe place. My recommendation is to buy an archival storage box. If you simply tuck your pictures away in any cardboard box, the contaminants in the cardboard will eventually wreak havoc with both your photos and negatives.

© ARCHIVAL METHODS

There is no rule stating that your wedding album must be finished immediately, but, as a lighthearted rule of thumb, it should be finished by the time your first child is old enough to want to see it!

PHOTOGRAPHS © PHOTOGRAPHY ELITE INC.

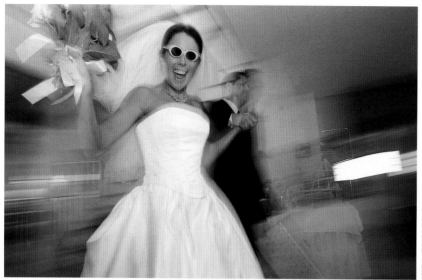

© GEORGE WEIR

Weekend Warriors: Less Costly than a Studio

If the major drawback to hiring students is their lack of experience, you might wonder if it is possible to hire someone more experienced than a student but less costly than a wedding studio. Many studios hire freelance photographers as sub-contractors. These shooters may also take assignments from the general public. Or, while holding down a full-time "day job," they might be building their photography business and reputation, or perhaps they are just using their talent to make some extra cash. In any event, these photographers are often called "weekend warriors."

Weekend warriors typically get assignments by word-of-mouth recommendations or small ads in local newspapers. Often clergypersons, camera stores, and photographic labs can recommend one to you.

Because weekend warriors are members of an unaffiliated, nebulous group, it is difficult to make general assumptions about services they offer and prices they charge. Some will just shoot the film, which you then take to a photo lab (often the one that recommended them), while others offer services similar to a photographic studio. Usually though, their fees for similar services are less than those of a "brick-and-mortar studio" because weekend warriors have less overhead.

One downside to hiring this type of photographer is that you could find yourself without a photographer if they break a leg right before your wedding. A larger, more established studio usually has many photographers on staff in the event of such a calamity. While the lack of a safety net is a disadvantage, one advantage is that the same photographer who showed you his samples will be there the day of your wedding. With a studio, unless you specify your photographer by name in your contract, you have no guarantee that a certain photographer will shoot your wedding.

When you interview a freelance photographer, look at his portfolio. Also consider recommendations you may have received of him or her. If you choose wisely, you will be very satisfied with the results.

Over $1,000: Wedding Photography Studios

If your budget reaches between $1,000 and $6,000, it is best to work with a professional photography studio. The price range here is broad because there are many variations in products and coverage available from a studio. A studio owner is faced with many choices from the start of an assignment through its completion, and each one has an effect on the coverage and product they deliver, and the price he or she must charge. To better understand what is involved, let's look at each step in the process from beginning to end.

Labor

During the peak of the wedding season, a wedding photography studio may have between ten and twenty-five wedding assignments on a typical weekend. Usually, a studio owner hires freelance photographers to cover those extra assignments.

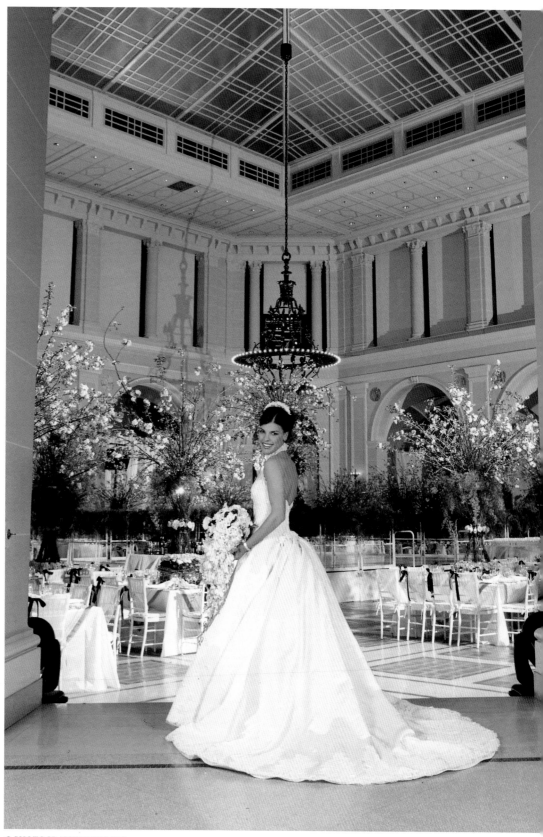

© PHOTOGRAPHY ELITE INC.

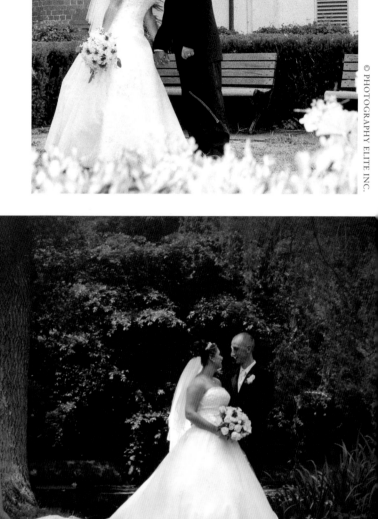

Don't be confused, a freelance photographer is not necessarily a less skilled or inexperienced photographer. The good ones equal or surpass studio owners in photographic ability. Why do they freelance? They might prefer not to deal with the public, or perhaps they don't like the paperwork or production work required. They prefer to shoot the photographs and let the studio make the albums and deal with the customers. Depending upon the quality and experience of a freelance photographer, wedding studios pay between $250 and $750 per assignment for their services, plus overtime. But remember, this is just a small part of the total costs a studio incurs in taking your pictures and making your albums.

While you may find it difficult to imagine that a photographer could be worth so much money, remember that certain photographers (who shoot things like magazine covers, advertising photographs, or portraits of CEOs) regularly get thousands of dollars per photograph. Great photographers can make you laugh or cry when viewing their work, as easily as a violin virtuoso can tug at your heartstrings with his elegant technique.

© FRANKLIN SQUARE PHOTOGRAPHERS

THE BRIDE'S GUIDE TO WEDDING PHOTOGRAPHY

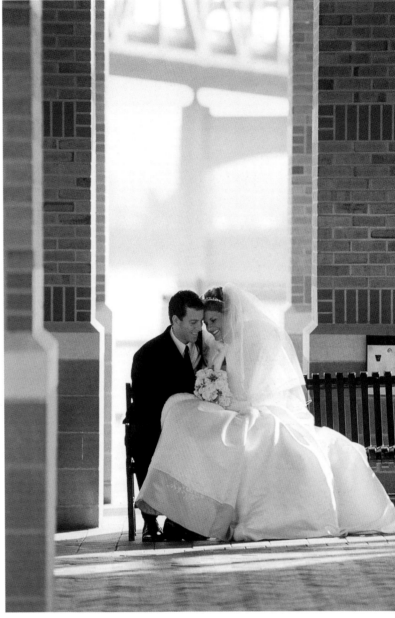

An Assistant Photographer Gets Paid Too

For some brides, a professional photographer with a flash on his camera may be fine, but other brides are often willing to pay extra for the photographer who works with a lighting assistant, realizing that better lighting usually leads to better pictures. Costs from $25 for a student to $175 or more for an experienced assistant are not uncommon.

Most studios realize that hiring a top-shelf, freelance photographer without an assistant is like buying a car without any options. Many great photographers are great, in part, because they have created a team with their assistant, and getting one without the other will decrease the quality of the product.

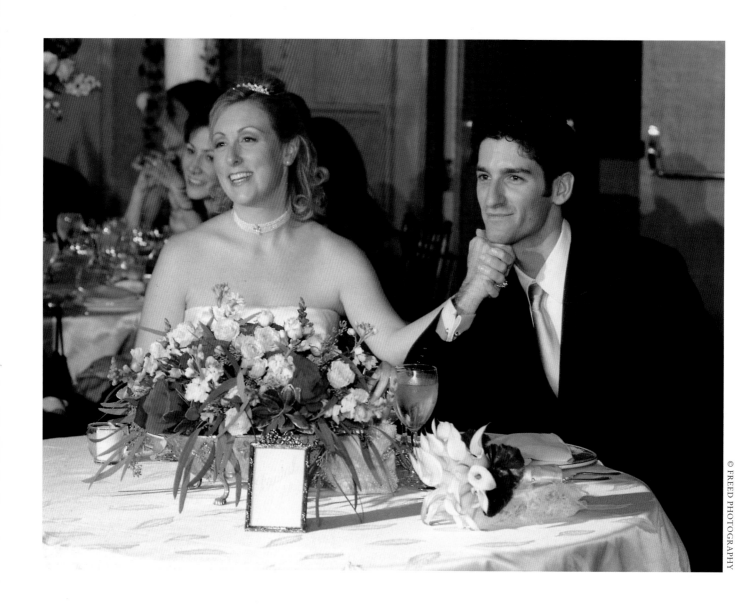

Want a Real Upgrade in Quality? Opt for a Second Crew!

In my own professional practice, I use two photographers and two assistants for every wedding assignment. This is not because I'm lazy—I just can't be in two places at once! I can't be at the far end of the aisle, as the bride and her dad proudly walk down it, and at the other end, capturing the intimate eye contact between dad and daughter as they take that first step.

To fully exploit the advantages of two photographers, a pro plans the placement and timing of each photographer to maximize photo opportunities. If you are looking into high-end wedding coverage, check to see if the studio you are interviewing offers the services of a second photographer. Ask what photos the second photographer will be taking. Studios that use multiple photographers effectively should be able to rattle off a list of photo ops for that second photographer. Also, in evaluating the price of additional photographers, remember that not only salaries, but also the cost of the film and processing for each extra photographer must be taken into account.

Another Popular Option

Another choice that is usually less costly than using a full second crew is to hire a photojournalist, or "PJ style," shooter in addition to the main photographer. In my geographic area, a PJ shooter creates black-and-white photos on 35mm film in addition to the crew shooting traditional photographs with medium-format cameras. When I first started offering this service, the PJ shooter didn't shoot portraits, but worked almost exclusively with available light (no flash). However, a funny thing happened as my PJ shooter and I started to work together more often. During my portrait sessions the PJ shooter, working from the side of the portrait "set," was able to shoot unobtrusive portraits because the people were concentrating on my camera. Even though he worked in a true PJ style — the subjects were unaware of him — his images improved dramatically. As I posed the people, I made sure ties were straight and the bride's veil didn't block her face. While I walked back to my camera, the PJ would shoot a few frames of film. This resulted in photographs that were totally less posed (compared to mine), and better still, that didn't have the sloppiness you sometimes get with pure PJ images. Once the portraits are over, he goes about his shooting and I go about mine, resulting in two sets of very different photographs for the bride. If photography is important to you, if you love the look of black-and-white (but not to the exclusion of color photographs), then this option offers an exciting variation that will make your album much more interesting.

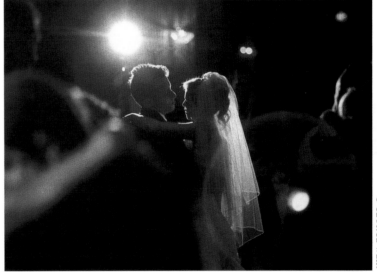

Over $6,000: An Exclusive Photography Budget

A small, select clientele can afford wedding photography budgets over $6,000. Usually, photographers catering to this exclusive audience do not offer a package with a specified number of prints, but instead have a fee that is all-inclusive. For example, instead of the typical wedding-photography package featuring one fifty-photograph, 8 x 10 bridal album and two twenty-four-photograph, 5 x 7 parent albums, the studio's flat rate would include two crews, unlimited hours, and three albums of any size with the number of prints limited only by the binding style.

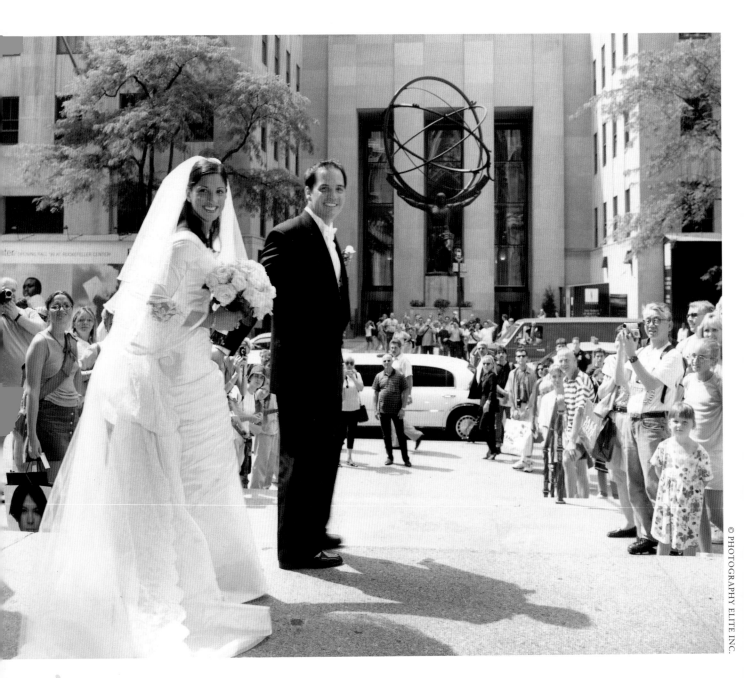

What About the Finished Product?

Although the variation in expenses might seem surprising, an 8 x 10 print can cost your photographer anywhere from $2 to $20! Here are some reasons for such a large range:

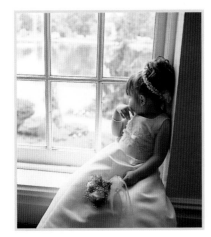
© PHOTOGRAPHY ELITE INC.

1. How carefully each print is color matched to others. Tight quality control usually results in more rejected prints, which leads to higher print costs.

2. Whether the print is carefully cropped by hand or if that process is done with standard templates by a machine.

3. Finishing, or whether the prints are retouched and sprayed with lacquer before you get them.

One studio I know has a retouching artist on staff who is paid over $50,000 per year. If that studio does 200 weddings per year, $250 of that person's salary has to be absorbed by each wedding order. Spraying prints with a protective lacquer, which can increase the longevity of your photographs, typically costs a photographer over $1 per print. If your photography order has over 100 prints in it — well, just do the math.

Wedding photographers often refer to the cover and pages of an album as "bindings." These, too, vary greatly in price and quality. For example, the least expensive 5 x 7-inch binding that holds 24 photos will be 1/10 the price of a bordered, leather-bound album of the same size. Obviously, the album or binding style your photographer offers will influence the price you are charged. If you are not sure, ask for details and options.

If you consider all the differences in these variations, you can see that a photographer is faced with wide range of costs for the materials and services available for delivery to you. While some choices may be more important to you than others, all must be considered in accordance with your wedding photography budget.

A Few Final Words

Feed the Photographer

It is a long day for photographers. They often start at the bride's home an hour before the ceremony and work continuously into the evening until the bouquet and garter are tossed. Shooting a wedding often requires ten or twelve-hours. There are few, if any, breaks because they don't want to miss the action. Although it is usually an oversight, brides and their parents sometimes forget to offer their photographer(s) a drink or some food.

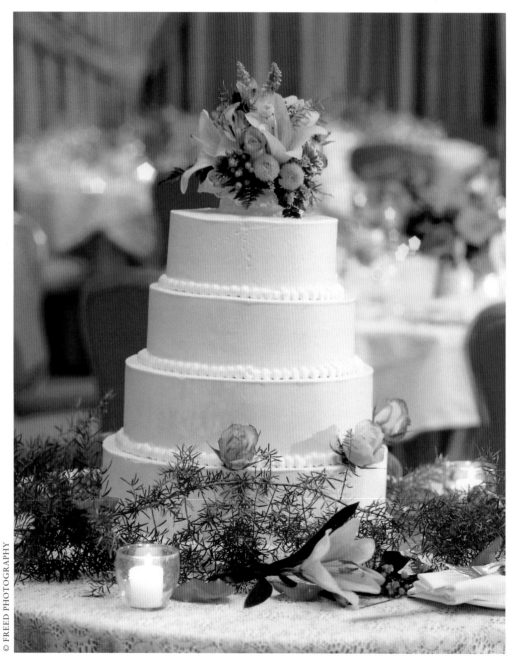

I once shot a wedding at one of New York's finest hotels. The assignment started at noon and the party was still going well after 8:00 in the evening. The bride had been on edge all day, with never a kind word for the hairdresser, make-up artist, florist, maitre d', bandleader, or me. During that time, my crews and I worked without a break, a bite to eat, or even a drink of water. Sometime after 8:00, one of the assistants ordered some Cokes and carried them over to the crew. Within seconds, the bride appeared and instructed us that we were hired to take photos, not to partake of her guests' beverages.

When she was finished speaking, I looked at my watch and said that we had been on this job for over eight hours without a break or bite of food, so we would now be going down to the hotel coffee shop for dinner. I suggested she notify the maitre d' so he could try to avoid any wedding photo-ops while we were gone. She sputtered and stormed off on the verge of tears. Seconds later her father appeared. After questioning me for a moment, he asked the maitre d' to feed the photo crew.

Now, I don't know if I would have actually pulled the entire crew off the assignment, but it is important to remember that you reap what you sow. While a true pro finds his rewards in doing the best job possible, no one can do their best after a long day with nothing to eat or drink. Hopefully, this story will help you remember to treat your photographers kindly, so they can take even better care of you—photographically.

Tipping

Here's the rule: you do not tip the owner of the studio, but it is appropriate—although not required—to tip workers. For example, if you hire Smith Studios and your photographer is Mr. Smith, there is usually no need to tip him. But if you hire Smith Studios, and your photographer is Mr. Jones, then a tip for a job well done is always appreciated.

Historically, the word "tip" is an acronym for "To Insure Promptness," because the tip was given before the job started. While a tip for your photographer at the end of the day will be appreciated, it does little to gain you special treatment. On the other hand, a tip for your photographer at the beginning of the day makes him think of you more positively from the start.

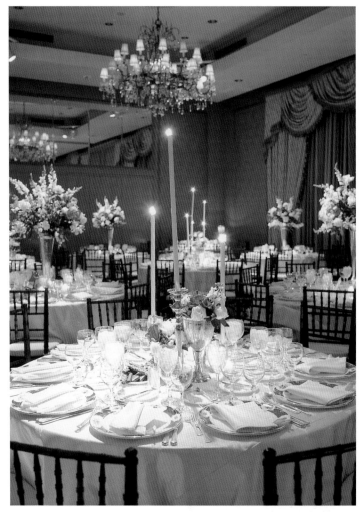

© FREED PHOTOGRAPHY

I have asked dozens of colleagues about this and every one said that they tried harder to do their best when tipped up front! To make any tip even more effective, have your dad (or the best man) give the tip for you. Have them say something like, "take care of my daughter" (or from the best man, "take care of these people, they're special to me"). This will reinforce the idea of how nice you are. Whether to tip at the beginning or end, or not at all, is your choice—you decide. But remember one thing, a tip that is too small (less than 1 percent) can be considered more an insult than a positive act of appreciation.

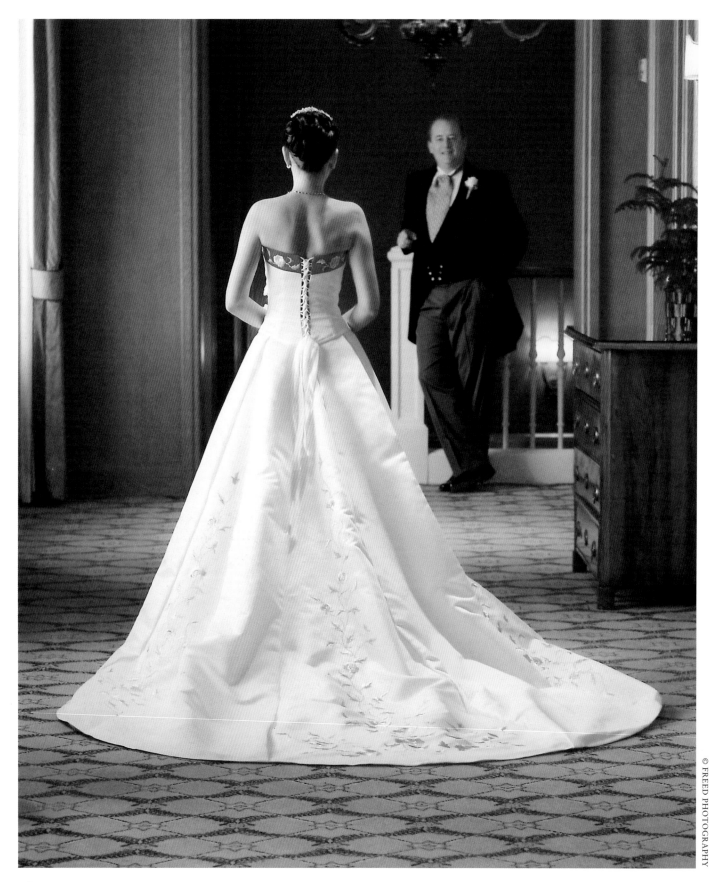

THE BRIDE'S GUIDE TO WEDDING PHOTOGRAPHY

A Sample Repertoire

A good photographer develops a list of photos he or she will try to capture, including formal and informal pictures that catch the different moods of the day.

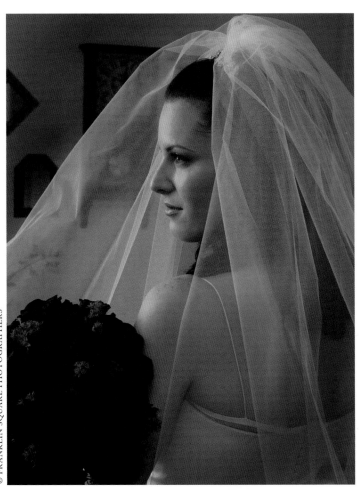

What pictures do you actually expect your photographer to shoot? I have compiled a general outline of what I cover at a wedding. It is not what all photographers might shoot, nor is the sequence written in stone. Many factors influence the final outcome, including the wishes of the subjects, family sizes, bridal party size, and other details. The photos can be posed or relaxed. Even if the pictures are all done in a non-posed style, most, if not all, of the photos on this list should get taken.

This repertoire is for professionals. Don't expect an uncle or friend to duplicate it. Professional photographers work quickly and can usually keep a running tally in their heads of what's been done and what still needs to be done. This is surprisingly hard work. If you ask a family member or friend to follow this list shot for shot, you will (a) no longer have a friend at the end of the day, and (b) doom that person to 6 or more hours of intense concentration with no spare time to enjoy themselves!

Importantly, this repertoire depends on having adequate time to shoot the photos. It demands about an hour at your home before the ceremony, and an additional two hours after the ceremony, before the reception starts. This may sound like a lot of time. But as a mentor of mine once said, "you can't make an omelet without breaking an egg." It is impossible to limit your photographer to 15 minutes and expect a stack of 200 pictures.

Whether uncle, friend, or professional, every photographer does his or her own thing to some extent, so you shouldn't expect to see a carbon copy of this list. But by looking through this outline and selectively choosing the photos you find important, you can help your photographer zero in on your desires.

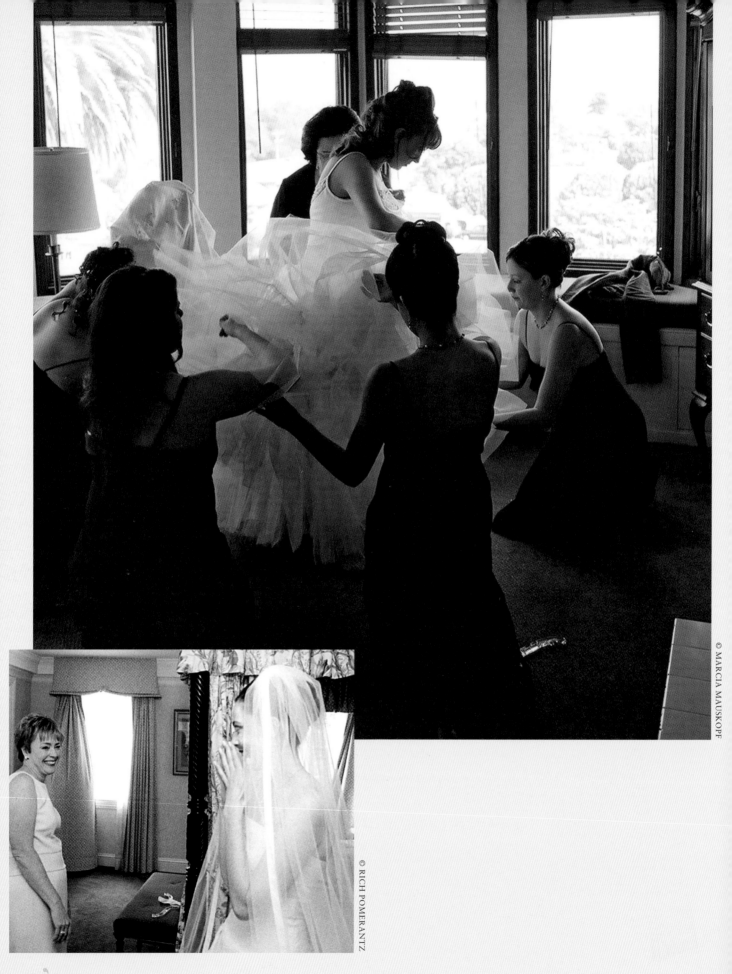

© MARCIA MAUSKOPF

© RICH POMERANTZ

The Bride's Guide to Wedding Photography

1. The Bride's Home

—The dressing room—

- The invitation with bridal bouquet and/or the ring bearer's pillow
- Mirror photos

 Bride using comb and brush

 Bride with compact

 Bride applying lipstick

 Bride's hands holding parents' wedding photo, with her reflection in the mirror

 Bride's hands holding invitation, with her reflection in the mirror behind

 Bride's hand holding engagement ring, with her reflection in the mirror behind

 Bride and mirror together
- Mom adjusting the bride's veil
- Bride and maid of honor

—The living room or yard—

- Bride and dad: formal
- Bride and dad: kissing him on the cheek or hugging him
- Bride and her parents: twice

 Bride and her parents: selective focus
- Bride's parents alone: twice
- Bride and mom: regular and soft focus
- Three generations: bride with her mother and grandmother
- Bride and sisters

 Optionally, bride with each sister or bride with all siblings
- Bride and brothers (and optionally, bride with each brother)
- Bride and bridesmaids (and optionally, bride with each maid)

 Bride and flower girl

 Bride and maid (and/or matron) of honor
- Bride alone: three to four close-up poses, two to three frames per pose

 Bride by window light: at least two
- Bride alone: three to four full-lengths, two or three frames per pose

—Leaving the house—

- Bride, parents, and bridesmaids in front of house
- Dad helping bride into limousine

2. The Ceremony

—At the Church—

- Dad helping bride out of limousine (or variations)
- Groom and best man: two frames (possibly a gag shot, too)
- The Processional

 Mothers of bride and groom being escorted down the aisle

 Each bridesmaid walking down the aisle

 Maid of honor walking down the aisle

 Matron of honor walking down the aisle

 Flower girl and ring bearer walking down the aisle

 *Bride and dad walking down the aisle: two
 or three frames*

 Dad's kiss good-bye

© MARCIA MAUSKOPF

- Readings or music (photos of speakers, singers, and musicians)
- Time exposures from rear of church or choir loft
- Exchange of rings

 Groom to bride

 Bride to groom

- Candle lighting (if there is one)

—Special Traditions—

- Mass

 Couple kissing at the Sign of Peace

 Bride and groom kissing/greeting parents at the Sign of Peace

 Drinking wine and/or receiving the host

 Presenting flowers to the church

- Other religious traditions

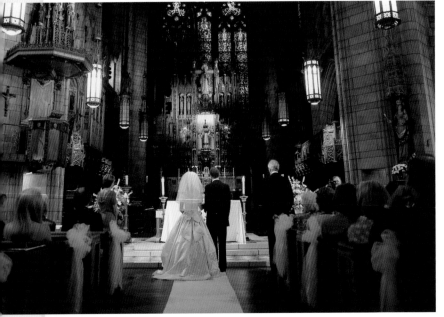

© PHOTOGRAPHY ELITE INC.

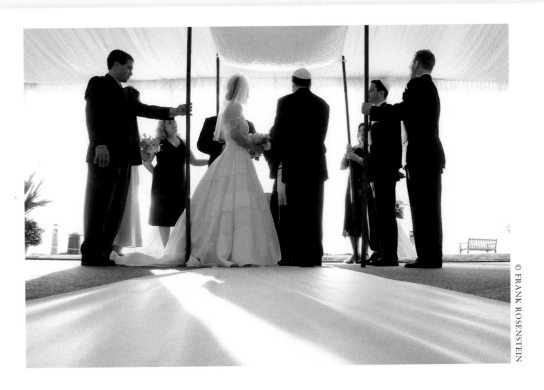

© FRANK ROSENSTEIN

—After the Vows—

- **The Recessional**

 Bride and groom: at least two frames

 Bride and groom kissing in the aisle at rear of the church

- **Receiving line (and it's aftermath)**

 Three to 24 candids

 Two quick pictures of the bride and groom with each set of parents

 Possibly pictures of the couple with their grandparents

- **Leaving the church**

 Bride and groom, silhouetted in church doorway

 Bride and groom with bridal party on church steps

 Same as "Receiving Line" photos but with thrown rice

- **Getting into the limousine**

 Shooting through the far door, looking in at the bride and groom

 Bride and groom looking out limousine window

 From the front seat looking into the back seat of the car

 > *Bride and groom toasting*

 > *Bride and groom facing camera*

 > *Bride and groom facing each other*

 > *Bride and groom kissing*

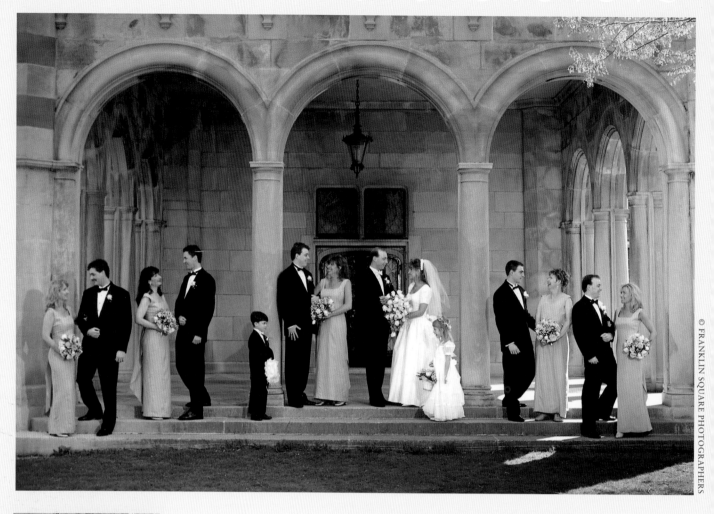

© FRANKLIN SQUARE PHOTOGRAPHERS

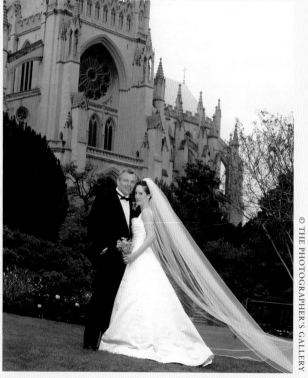

© THE PHOTOGRAPHER'S GALLERY

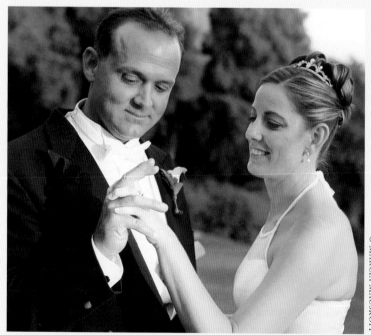

© MARCIA MAUSKOPF

THE BRIDE'S GUIDE TO WEDDING PHOTOGRAPHY

3. Formal portraits

—The bridal party—

- Bridal party together

 Both formal and some gag shots of the bridal party
- Groom and ushers (and optionally, groom with each usher)
- Bride and bridesmaids
- Bride, groom, maid (or matron) of honor, and best man
- Bride and maid (or matron) of honor
- Groom and best man
- Groom alone: four to six poses, two or three full-lengths and two or three close-ups

—The bride and groom—

- Six to eight photos, three or four different full-lengths and close-ups
- Variations on the bride and groom portraits

 Close-up of rings on hands

 A scenic image

 Bride and groom: selective focus

—Worthwhile additions—

- A few additional full-lengths and close-ups of the bride
- Any bridal-party couples
- Groom with his siblings in the bridal party
- Relaxed group photo of the bridal party around the limos

© FRANKLIN SQUARE PHOTOGRAPHERS

© MICHAEL ZIDE

© MARCIA MAUSKOFF

© GEORGE WEIR

© THE PHOTOGRAPHER'S GALLERY

THE BRIDE'S GUIDE TO WEDDING PHOTOGRAPHY

4. Family Photos

—The groom's family *(bride's were done earlier at her home)*—

- Groom and his dad (twice)
- Groom and his mom (twice)
- Groom and his parents (twice or thrice)
- Groom's parents alone (twice)
- Groom and his siblings
- Three generations: groom's side (groom, his dad and his dad's dad)

—Family: bride and groom together—

- Bride with groom's parents (twice)
- Bride and groom with groom's family
 With and without grandparents
- Bride and groom with groom's siblings
- Bride and groom with groom's grandparents
- Bride and groom with bride's parents (twice)
- Bride and groom with bride's family—with and without grandparents
- Bride and groom with bride's siblings
- Bride and groom with bride's grandparents

—Family: others—

- Grandparents alone or as couples
- Extended family: bride (aunts, uncles, cousins)
- Extended family: groom (aunts, uncles, cousins)

© THE PHOTOGRAPHER'S GALLERY

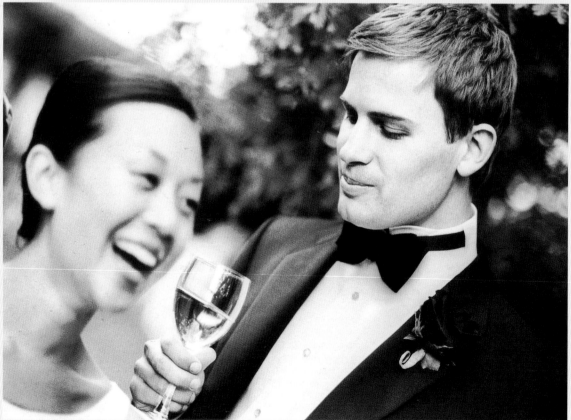

5. The Reception

—The Entrance—

- Siblings
- Best man and maid of honor
- Flower girl and ring bearer
- Bride and groom: twice or thrice

—The First Dance—

- Bride and groom: two to three full lengths and possibly a close-up
- Bridal party couples (especially married ones)
- Parents
- Grandparents

—The Toast—

- Best man toasting
- Bride and groom with best man and toasting glasses, if possible
- Bride and groom toasting each other

—Table pictures—

- Tables for both sets of parents
- Tables of friends
- Special tables (cousins, co-workers etc.)

—Candids: 50-200 photos—

- Bridal party: friends
- Guests dancing
- Groups on the dance floor
 *Photos of couples dancing: faces
 toward the camera*
 Three and four people groups
- Large, impromptu groups
 Friends
 Co-workers
 Families

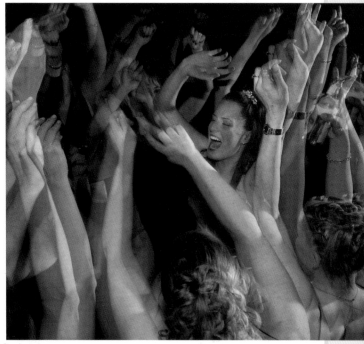

© FRANKLIN SQUARE PHOTOGRAPHERS

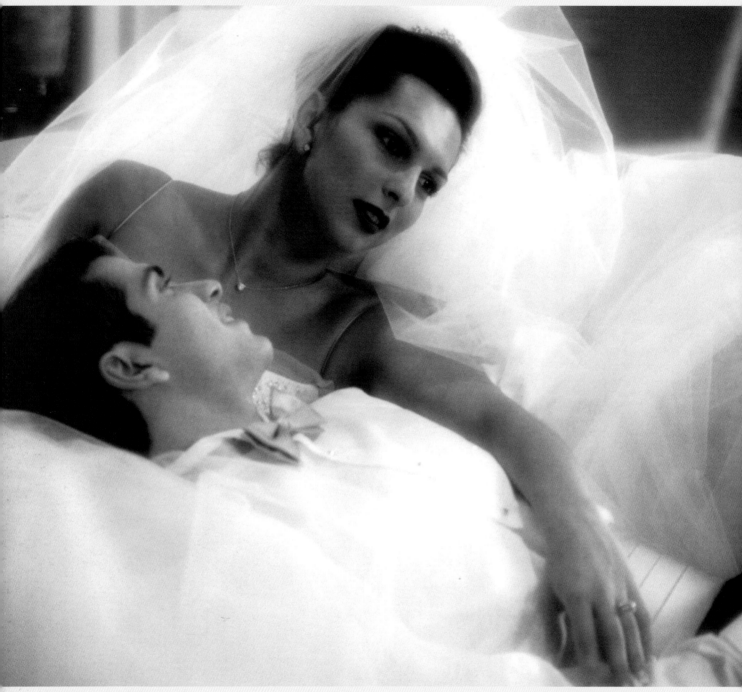

© FRANK ROSENSTEIN

© FREED PHOTOGRAPHY

—Special dances—
- Bride and dad dancing
- Groom and mom dancing

—Romantic photos—
- Candlelight photos
- Good-bye shots or gag shots
- Available-light night scenes, including reception hall scenery

—The cake—
- Bride and groom cutting the cake: twice or thrice
- Bride feeding the groom
- Groom feeding the bride
- Bride and groom kissing each other with cake in composition

—Bouquet and garter toss—
- Tossing bouquet
- Removing garter
- Tossing garter
- Putting garter on bouquet catcher's leg

© PHOTOGRAPHY ELITE INC.

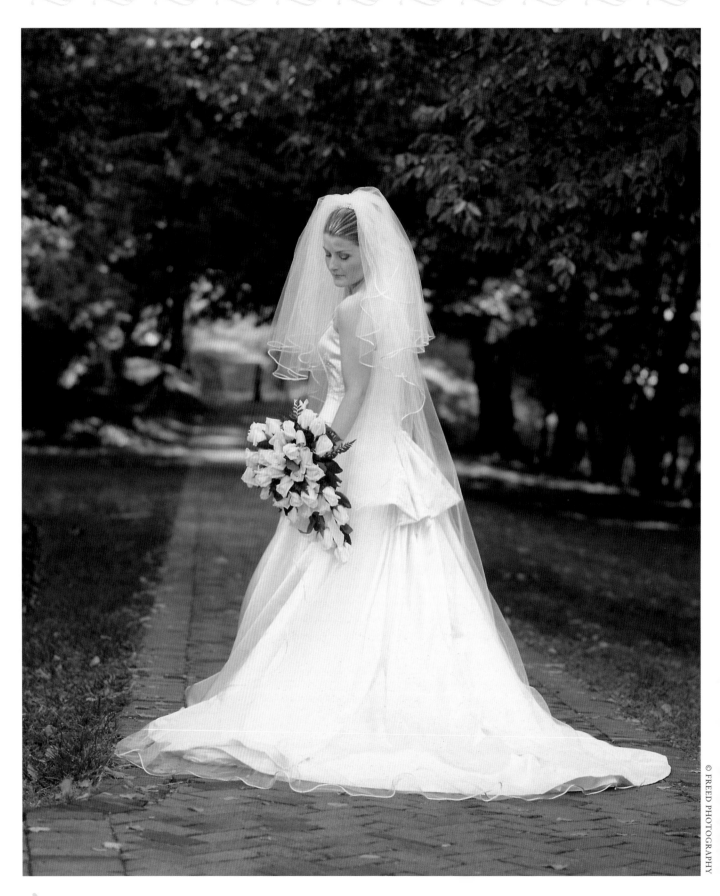

THE BRIDE'S GUIDE TO WEDDING PHOTOGRAPHY

Tangibles: Negatives, Proofs, Prints, Albums, and More

You are busy planning a beautiful day, but take a second to learn about photographic options so you can make the best choices about your wedding photography…or the best decisions about your wedding photos.

This chapter focuses on the products your photographer will create for you. The basic building blocks for your wedding photographs are negatives or digital files. In addition, other tangible items include proofs (to preview the images), prints, and of course, your albums. In order to discuss these, I need to clarify technical concepts in this chapter, briefly explaining cameras, film, digital files, and other photographic principles. While it isn't necessary to understand how the entire operation works, a basic knowledge of the photographic process will help you choose the best products and services possible from your photographer. You'll be a better-informed shopper once you've read this chapter.

Sadly, there are some photographers who may try to intimidate you with complicated technical jargon and their photographic expertise. After reading this book, you will be better equipped to deal with these types of photographers as you choose the person to shoot your wedding.

© PHOTOGRAPHY ELITE INC.

Relax, it's not necessary for you to know the difference between an f/stop and a bus stop. It's not your job to be a professional photographer; it's your job to be a beautiful bride. So don't worry, there's no test at the end of this section.

Bigger is Better! More is Better!

Your images can be captured on different sizes of film or digital files. When shooting with traditional film, bigger negatives offer better image quality. The difference in quality is called sharpness or resolution, and in general, higher resolution is better than lower resolution.

If you want big, clear, saturated enlargements, medium format negatives offer an advantage over other photographic formats. When interviewing photographers, don't forget to ask them what size film they shoot.

35mm is a common film size used with cameras like Nikons and Canons. Roll film (medium format) is larger than 35mm and therefore creates a larger negative, producing pictures with higher resolution and expanded tonality. Expanded tonal ranges mean creamier skin tones—a feature that is attractive in wedding photos.

When using digital photography, files, like negatives, can be defined by a range of sizes. More data require larger files than less data, and consequently offer images with greater sharpness and resolution.

THE BRIDE'S GUIDE TO WEDDING PHOTOGRAPHY

The resolution question becomes even more an issue with films that are considered fast. Fast film is used for low-light photography because it requires less light to produce an image than slower film. However, it also produces images that are less sharp. Just as with film, a digital camera can be set for higher or lower sensitivity to light. But in digital photography, this lower resolution and sharpness is termed as "noise".

The Film Negatives

Today's 35mm cameras have automated features that make them perfect for covering parts of the wedding where action is occurring. These include the ceremony, parts of the reception, and other events that require the speed delivered by a 35mm camera.

To get the best images possible, however, many professional wedding photographers work with the medium format cameras, which are larger than 35mm cameras. The bigger negative offers superior resolution, especially visible in portraits because the increased tonality enhances the reproduction of skin tones. Most of the finest photography studios in the country use medium format cameras as their standard.

Choosing Between 35mm and Medium Format:

1. Medium format film costs more per photograph. This is directly connected to how much a photographer charges. If expense is a top concern, you can probably get more bang for your buck if the photographer uses 35mm equipment.

2. If you are never going to make prints (or an album) larger than 6 x 8 inches, you probably won't see a difference between 35mm and medium format photographs.

3. If you have your heart set on a high-quality 16 x 20-inch (or larger!) wedding portrait, then it is almost mandatory to choose a photographer who uses medium format equipment.

4. If it is important that the photographer sells his or her negatives (yes, they belong to the photographer) to you, then you should understand it is much more difficult to find a photographic lab that handles medium format than one that handles 35mm (which might be as close as your local drug store).

THE BRIDE'S GUIDE TO WEDDING PHOTOGRAPHY

Do You Really Want Your Negatives?

Couples sometimes want their photographers to include the negatives as part of the deal. This is often requested because couples want to save on the cost of making extra prints. Even if savings can be achieved, it is not always the best idea to choose your photographer based on whether or not they will let you purchase the negatives.

The concept of selling wedding negatives is a recent trend among some photographers. They may orient their sales pitch around the claim that they simply like to shoot, and they don't want to be bothered with making prints. They will point out the financial savings you can attain when you do the legwork yourself to have the prints made.

However, there are also drawbacks. Once you have your negatives, you are on your own. A photographer who doesn't have to produce prints for you may not offer the same level of quality control as one whom will see the job through to completion. They do not have the incentive of extra print sales and might not care enough to do a great job in shooting the pictures. They may not go that extra mile because the lure of a highly profitable order for extra prints doesn't exist!

Certainly this is not always the case. There are many photographers who do a great job just because they get an inner satisfaction from a job well done. But before you commit to a photographer who will just shoot your wedding and give you the negatives, make sure you understand all the consequences.

For those of you who want your negatives as a security blanket so you can keep them safe and always know where they are, here is a suggestion. Explain to your photographer that you want your

© RICH POMERANTZ

negatives for security reasons as opposed to budgetary ones. One reason photographers want to retain the film is because they increase their profit when you order additional prints and albums. So guarantee to order extra wedding photos in return for the negatives. Alternatively, you might offer to purchase the negatives for a nominal fee one year after the albums are delivered, because 99% of all reprint orders have been placed by then.

© GEORGE WEIR

The Digital Daze and Craze

In a way, digital cameras work the same way as traditional cameras. But instead of film, digital photographs are recorded as pixels on electronic media, thought of as "digital film." In traditional film photography, the original is called a negative. But in digital photography, the original is called a file. Both mediums can be used to create excellent photographs. But each has advantages and disadvantages.

Current professional digital cameras are now equal in quality to 35mm cameras. But most do not yet equal the quality available from roll-film cameras. They also have limitations in recording detail in the highlights, or white areas, of a scene. Since bridal dresses are big white objects, this should be of particular interest to you. These limitations are certain to be overcome in due course. In fact, given the speed with which digital quality is progressing, it is safe to say that digital will be the medium used for the majority of wedding photos within a few years. The advantages are too great for that not to happen. Yet right now, film has quality advantages over the digital medium for capturing wedding photos.

But Is It Less Expensive?

Considering that digital photographers do not have to buy film or pay for film processing, digital photography should result in savings for budget-minded brides. In fact, there are savings when photographers switch to digital imaging. However, these savings are more than offset by image-editing requirements, the cost of new, high-end camera equipment, and the need to constantly upgrade computer gear. Eventually, as digital quality surpasses film quality and the equipment becomes usable for a longer period of time, the escalation of costs will slow and real savings can be generated. But, for now, the extra costs must be passed on to you, the customer.

© MICHAEL ZIDE

The Creative Revolution

The switch to digital imaging is also bringing about new creative possibilities in both special and traditional effects. One simple example involves changing a color photograph to black-and-white. There was a time when black-and-white photography was the norm — color wasn't even a choice. But color film eventually replaced black-and-white as the leading medium for wedding photography. Because everything happens in cycles, after 20 years of primarily color photography, many brides have again begun to ask if they can receive some of their photographs in black-and-white. While it is possible to get black-and-white prints from color photos, the results are often less than satisfying.

In digital imaging, all files are shot in color. But changing a digital color image to black-and-white is just a mouse-click away. Digital manipulation also lets your photographer do so much more. Imagine a black-and-white portrait of the bride (you!) holding her bouquet...but now imagine that the roses in the bouquet are red. This effect can be done easily. Again, it's only a mouse-click away.

If emailing copies of your wedding photos to far-flung family and friends is important to you, having digital files of your wedding pictures is a convenience. Most digital photographers supply their customers with low-resolution CD's that contain images perfect for this usage. You may, on the other hand, use traditional photographic proofs as gifts for family and friends who are not yet part of the digital experience. You will want to decide whether traditional proofs or digital images suit your needs best, then discuss those needs with your photographer.

© FRANKLIN SQUARE PHOTOGRAPHERS

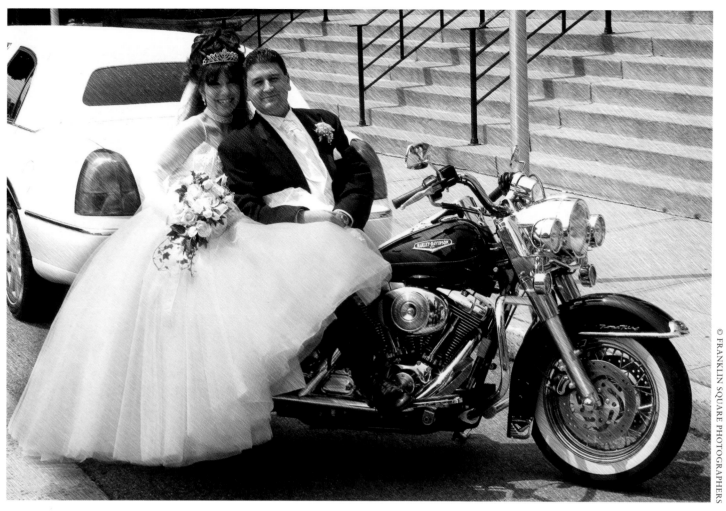

Don't pass up opportunities to express what makes the two of you unique. Photos such as this will often turn out to be your most treasured memories of the day.

Combined with new digital imaging possibilities such as the painterly effect demonstrated here, your photos can be just as individual as you and your groom.

THE BRIDE'S GUIDE TO WEDDING PHOTOGRAPHY

Proofs

Before you get your final prints, there has to be some method of choosing which pictures you want for albums, frames, and gifts. The most common name for these small selection photos is "proofs" (though they are sometimes called previews, contacts, enlarged contacts, or test prints). Even though each type can differ slightly, I will use the term proof for a small print with numbering and/or ordering information stamped on the back.

In recent years, a new process for reviewing and choosing photos has emerged. There is now a tendency among a number of studios to go "proofless." A proofless system does not supply traditional proofs.

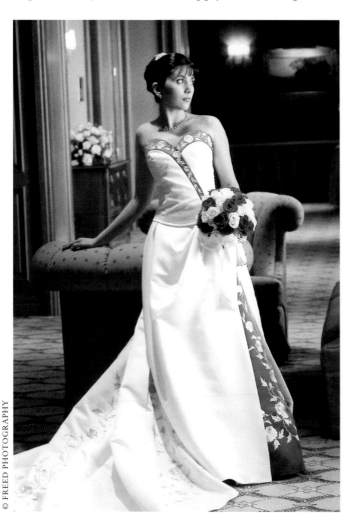

© FREED PHOTOGRAPHY

Proofless Methods for Photo Review:

1. **A low resolution CD of your photos, which is good for computer monitor viewing, but not good enough to make high-quality prints.**

2. **Contact sheets, which have postage-stamp sized images.**

3. **Enlarged contacts, which are slightly larger than regular contact sheets.**

4. **Any combination of these, or**

5. **No proofs at all!**

The proofless process gains traction from current hype that implies any new technology is better than old technology. The whole system is sold as a modern alternative to traditional proofing systems. Studios that promote proofless systems want to be more involved in your album selection and design. After the photographs are taken, the wedding studio shows them to the bridal couple on a monitor. Note that this is all done at the photography studio. There are definite advantages to this system. The lab that makes the finished prints can be linked electronically to the photography studio, so the studio doesn't have to handle and prepare each negative for printing (a time consuming process). Also, the studio can more easily demonstrate on the computer monitor the creative possibilities that are available for both the final prints and album pages.

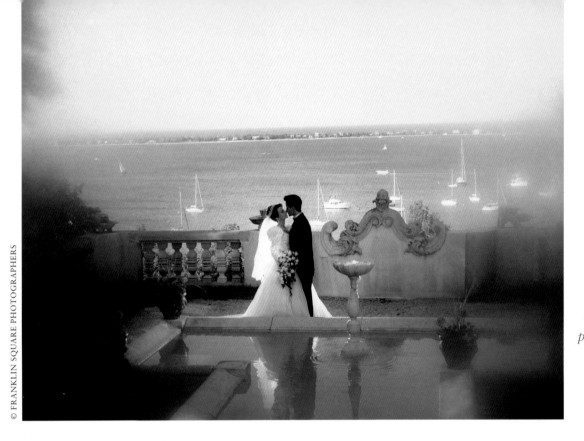

The photographs produced by excellent wedding photography studios are destined to become nearly priceless as years go by.

The Big Secret

At the risk of having other professionals place a contract on my shutter-button finger, I am going to tell you a big secret about proofless systems. Rarely mentioned is the fact that orders placed using the proofless system are invariably much larger than orders created by brides as they sit around the kitchen table, leisurely sorting through a stack of traditional proofs with family and friends.

Bigger Orders With a Proofless System:

1. In the privacy of your home, your mom or other family members may remind you that you still don't have a dishwasher, a fact that may take priority over the purchase of 20 extra photographs for your wedding album.

2. In the proofless system, an experienced sales-person leads you through the selection session. It's all too easy for you, as a starry-eyed bride, reveling in the memories of your wedding day, to buy one of everything. You see it and you want it, so there are many spur-of-the-moment sales made during this session. Even if you are aghast at the final bill and decrease the order, it will generally remain larger than what you would have ordered without the salesperson.

3. Because the proofless system doesn't include a set of printed photos, the only pictures you will have are ones you order. This fact alone makes it hard to disregard almost any photograph of your special day.

THE BRIDE'S GUIDE TO WEDDING PHOTOGRAPHY

This is not meant to discredit such benefits as speed, simplicity, and creativity found when using the proofless systems. But just remember that photography studios are businesses. They walk a fine line as they try to stay profitable and are heavily focused on maximizing sales.

Copyright and the Cost of Proofs

An often misunderstood question between photographers and bridal couples concerns ownership of the images. This has been an issue since the first time money was exchanged for a photographic portrait.

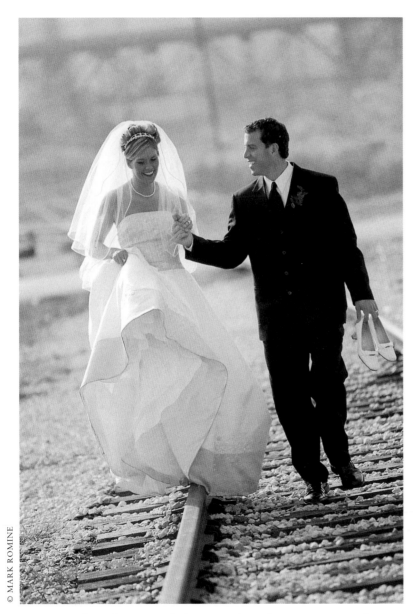

Less formal, unposed photos such as this are an example of what is called photojournalistic or P.J. style

Regardless of the amount they pay for their wedding photographs, brides and grooms think it is a lot of money! They also feel that the proofs have little or no value to the photographer, and since they are paying a fee, they should be able to do as they please with the proofs and pictures. While this argument seems to have merit, it doesn't stand up to the reality of the situation.

You may possess the piece of paper an image is printed on, but you don't own the image itself. It is the photographer's work of art, and is protected under copyright laws. While you have paid for the print and the license to view and display it, you don't have the right to put it in a scanner and sell or distribute copies of it.

In fact, most contracts with photographers clearly state the photographer is contracted to produce an album of wedding photographs, and they further state that the negatives (or digital files), proofs, and copyright remain the property of the photographer.

With regard to proofs, each one can cost the photographer between 50 cents and one dollar to produce. From the photographer's point of view, he or she is spending between $250 and $500 for an intermediate step that isn't even part of the finished product. Since wedding photographers are businesspeople who must remain profitable, they must make certain decisions about your proofs.

Photographers Can Consider Several Different Choices:

1. They can predetermine the number of photographs taken to accurately gauge their costs ahead of time.

2. They can build a large cushion into their pricing structure to cover the costs of unlimited film, processing, and proofing. Note that this tactic makes it difficult to remain competitive compared to other photographers who adhere to the first school of thought.

3. They can sell the proofs as an extra item above the price of their basic contract.

For studios to remain both competitive and profitable, they must deal with the proof issue. Yet the bride has a natural desire to get as many photographs as possible from her photography budget. There is no easy answer here, but one final point is relevant. While competent wedding photographers are plentiful, great wedding photographers are rare, and great photographers don't sell their talent and services cheaply. The product they're creating is designed to capture and preserve a moment in time so it can be enjoyed endlessly.

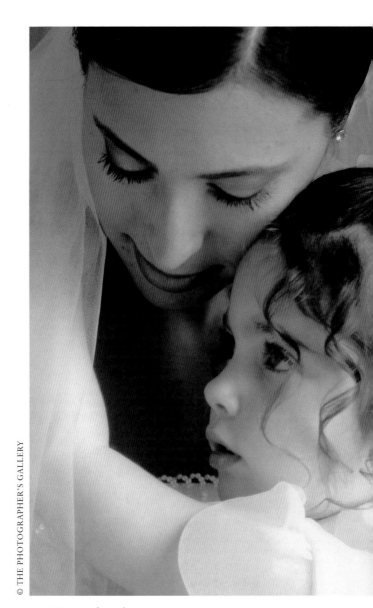

Remember that your pictures are a work of art and the copyright belongs to the photographer who created them.

THE BRIDE'S GUIDE TO WEDDING PHOTOGRAPHY

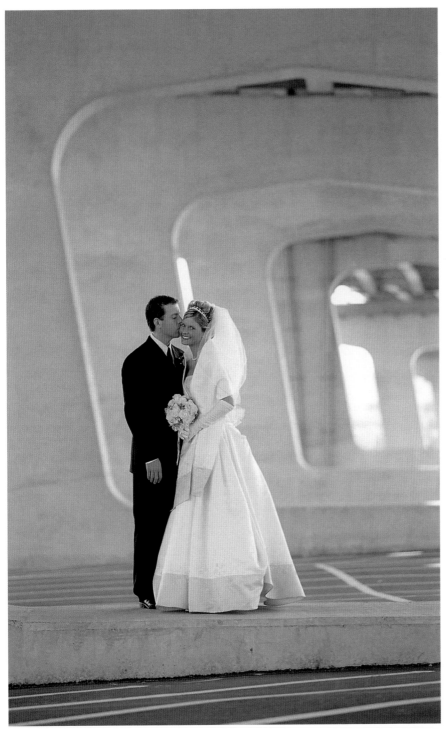

© MARK ROMINE

Prints

Wedding photography is important because it is a product that spans time. Your wedding photographs are the very first chapter in your new family's history, the beginning of a family archive. Because of this, you, as the newly crowned family archivist, should be interested in making sure the photographs from your wedding will last. While it may seem like a boring topic, the idea that your wedding photographs may fade into nothingness is something worth considering.

The Impermanence of Color Prints

When color photography first arrived, color photographs (prints) were remarkably unstable (the opposite of archival, which means a print will last at least 100 years). Though manufacturers have worked hard at making their products more fade resistant, color dyes do fade over time. All color photographic-paper manufacturers state that their products will last longer in "dark storage" combined with low humidity and cool temperatures. While no one expects you to keep your wedding pictures in dark-storage laboratory conditions, an album offers better protection for your photographs than hanging them on the wall in a bright, sunny room.

Tangibles: Negatives, Proofs, Prints, Albums, and More

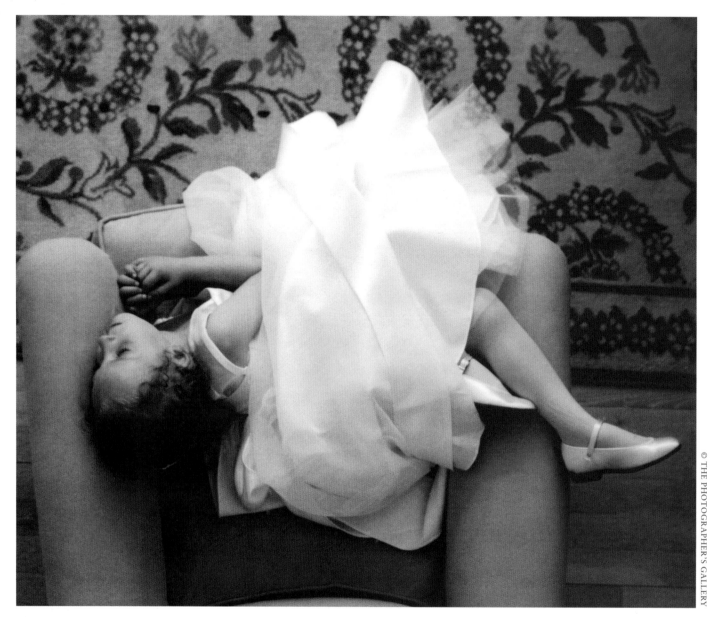

*Little girls grow up
and special moments like this
don't last forever.
That's why it is especially
important to take good care
of your wedding
photographs. Make sure that
your pictures are displayed
and stored using archival
materials, which will help
prevent fading, discoloration,
and other damage.*

Beware of Ink Jet Prints!

The discussion about dark storage pertains to prints made using traditional silver-based photographic paper. But a few photographers sell ink jet prints to brides. I find this alarming because the vast majority of current ink jet prints are nowhere near archival. Some photographers offer ink jet prints for wall display with the artistic sounding name of giclée, which is French for "spurt" (ink jet printers spurt the ink out of tiny nozzles). They may point to the archival quality of the paper, yet gloss over the fact that it is the inks that will fade! Moreover, they often may say things such as, "These fine prints are much like original watercolors and must be protected from sunlight and florescent lighting."

It is important to realize that just because a photographer uses a digital camera, it does not mean that he or she is delivering ink jet prints. There are machines that print digital files on traditional color photographic paper. When it comes time to choose your photographer, I recommend that you demand traditional, silver-based, photographic-paper prints.

As time passes, print longevity from ink jet technology is sure to improve. But at present, you want to be certain that you will be looking at your wedding photos on your 10th, 25th, and hopefully even your 50th anniversaries.

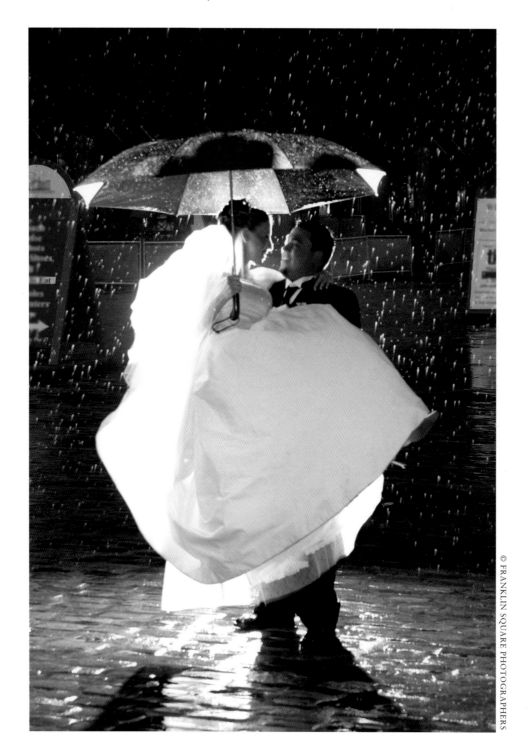

Albums

There are literally dozens, if not hundreds, of album types and styles. Although the most important function of your album is to protect your photographs, it is also true that a beautiful binding sets the stage for presenting your wedding photos to friends. An album style can be selected with either economy or luxury in mind, but most importantly, the type and style of album you choose should reflect your taste and personality.

"Slip-in" and "library-bound" are the two primary styles of albums, each with its own subcategories. As the names imply, slip-in albums require you to insert your photographs into mats (paper frames), clear envelopes, or pages, and these inserts are attached together in one of several ways. Library-bound albums feature photographs that are permanently mounted to cardstock backing by a dry-mounting technique. These mounted prints are attached to linen hinges that are stitched together.

Slip-in Albums

Slip-in albums are less expensive to produce than library-bound because their pages are more adaptable and they can be pre-ordered by the photographer. Beautiful and unique designs for slip-ins are available. Some feature open mats that hold the photographs. These have a metal rod running along one end that is sprung into a plastic clip, which in turn is cemented to the spine of the book. Often this type of album has a luxurious look.

Mats in a choice of colors, with or without colored liners, are available in oval (both vertical and horizontal) and diamond shapes, as well as the more conventional square and rectangles. There are also multi-image mats that allow you to place more than one photo on a page.

These page-design options are nice, but while a single oval or diamond mat is unique, a dozen, one after the next, become boring and lose the distinctiveness of a solitary shape. Further, the more images you place on a page, the smaller the images must be. If, for example, you have a two-page spread containing four photos of large family groups, these four pictures will become a hopeless jumble of tiny-faced people whom you can't really see. Save the multi-image pages for close-ups of one, two, or three subjects.

Post-bound Albums—Your mom's (and possibly even your grandmother's) wedding album may well be a style that has plastic or acetate envelopes into which a mat and the photograph are slipped. These pages are fastened between cardboard front and rear covers. Metal posts with screws hold the whole thing together. These are called "post-bound albums" and they are still used today

Library-bound Albums

A library-bound, stitched book is custom-made to fit the contents and possesses an elegance that surpasses most slip-in styles. Unfortunately, these library editions are becoming a lost, and therefore expensive, artform.

Library-bound albums are available in two basic types: The flush style where the photograph is the entire page, or a bordered style where there is a mat around the photograph. There are advantages and disadvantages to each. Either way, all photographs displayed in this album-style should be sprayed with a specially formulated protective lacquer. This coating increases the photo's longevity, protecting the prints from skin oils, airborne contaminants, and ultra-violet rays. Even prints for slip-in albums should be lacquered, but the process makes the prints more costly and adds to the production time in generating your albums and prints. If you are interested in the ultimate in quality and permanence, ask your photographer if he or she sprays their prints with photographic lacquer—it can make a difference.

The Flush-bound Library Book — Flush means that the photograph takes up an entire page. An 8 x 10, leather-bound library album is only slightly bigger than the photographs it holds. While its compact size makes it easy to handle and allows it to comfortably fit onto a coffee table or bookshelf, there are some disadvantages in this design. The shape of the book is vertical, and since it may contain some horizontal images, you must rotate the book 90 degrees to correctly view a horizontal picture. If vertical and horizontal photographs are arranged without thought to their orientation, you will constantly be rotating the book back and forth.

One solution is to consider a square album, which has no vertical or horizontal formats to worry about. An 8 x 8, 10 x 10, or 12 x 12-inch album offers a unique presentation that is also manageable in size. Square albums are more costly than rectangular ones, however. Also, they work best if your photographer shot the original negatives on a medium format camera (which is more costly than 35mm), because the smallish, rectangular-shaped 35mm negative needs to be cropped to fit the square proportions, which reduces the quality of the prints.

Bordered Library-bound Books—This type of album features a mat surrounding the photo and is generally the most expensive kind of album available. The style offers the advantages of high-end slip-in albums, but is bigger and bulkier than a flush-bound. Because photographs up to 8 x 10 can be oriented either vertically or horizontally on it's square pages, this style does eliminate the book-rotating problem associated with flush-bound albums and offers protection for the edges of the photographs.

Album Presentations

There are several exciting variations you can choose for either slip-in or library-bound styles of albums. These different presentations can make your album more special and interesting.

Covers

Front and rear covers for albums are available in materials such as linen, plastic, bonded leather (a leather product made of ground-up leather bits that are pressed and glued into a sheet), full-grain leather, and even wood. Covers can also be imprinted with names, dates, ornamental details, and some accept a cameo photograph. A wide range of colors is available, plus there are processes in which a photograph is printed as a wrap-around image covering both the front and back of the book.

Panoramas

An interesting upgrade is to include one or more panorama spreads in your album. These feature a large horizontal photo on a two-page spread. In a bordered 12-inch album, a matted panorama would be 12 x 24. In an 8 x 10 flush album, the panorama would become 10 x 16. Scenes that make good panoramic spreads include pictures of the bridal party, the church, members of the entire wedding party with the limo, or the reception hall. Another variation on the panorama includes two 5 x 5 shots placed one above the other on the far left or right side. For example, the full bridal party as the panorama, with two separate 5 x 5s on a side—one of the ladies and the other of the guys.

Montages

The newest trend in albums is the montage style. This type of album is usually created digitally by the bindery.

You choose the images, and the binder will place them in the design. With this style of album, you often forfeit control of picture placement, so you may prefer an option that allows you final approval of the design and sequence. A digital album may also be made with existing templates or the studio's own design.

The Do-it-Yourself Approach

One economical solution for budget-minded brides is to hire a photographer to produce just the prints. You can then create your own albums using the professional's prints combined with your own special pictures or meaningful objects. The resulting album, if done with care and imagination, can be both beautiful and unique. Pages might include copies of the wedding invitation, scraps of paper on which vows were written, and even pressed flowers, generating a one-of-a-kind product that is filled with significance and emotion.

If you go this route, whether for budgetary reasons or just because you're creative and enjoy it, be aware that some cements, papers, and plastics give off vapors as they age that can damage the pictures. Look for archival-quality mounting materials that will not harm your photos. There are many books available on the market about making scrapbooks and preserving photos and memorabilia.

In the end, you are the one who designs your wedding album. You decide which photos are chosen and the order in which they are presented. I can't tell you how many brides I've known who gave no thought to the order in which their photographs appear. This is a pity because poor choices here can make your wedding album routine and uninteresting.

Your Album—Making it Interesting

To get an idea of how the sequence can affect the quality of your album, here are a few do's and don'ts:

1. Do try to tell a story with pictures about your wedding day. Maybe start with a few photos of the stars of the day—you and your fiancé. Perhaps you show portraits of each of you separately; after all, you're not married when the day starts! Think of placing the pictures in a loose chronological order—that means you don't put a photograph of the bouquet-toss before one of the ceremony.

2. Don't use 12 consecutive photographs of yourself (the bride), no matter how great you think you look.

3. Don't put a photograph of your dad walking you down the aisle followed by a photograph of your husband walking you back up the aisle. Something happened between those two events—the ceremony!

4. Do look through your proofs for a special beginning photo (a picture of the invitation is a good idea because it sets the stage by identifying the players, the date, and the place). Also choose a final photo (something from the end of the celebration that's casual or

romantic might work, or maybe something symbolic like two champagne glasses or the top tier of the wedding cake). Remember to look for images that bridge the gap between one set of events and the next.

5. Don't put all the portraits together. Try to break up groups of portraits with other things that happened during the day. This establishes a break and sets a comfortable pace for the viewer.

One way to interrupt the flow of your portraits is to separate those shot of you and your groom individually from those where you appear as a couple. You might place the individual portraits in front of the pictures of the ceremony, while placing the "together" portraits (including family) after the pictures of the ceremony—but before those of the reception.

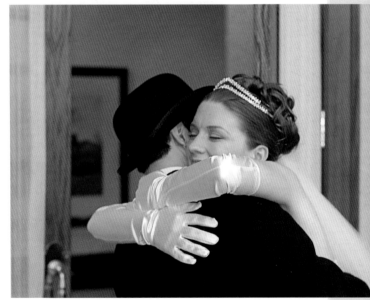

6. Think of how each photograph relates to its neighbor. Try to compose attractive, logical two-page spreads. An example of a "good" two-page spread might be a photo of you opposite a picture of your groom. An example of a "bad" two-page spread might be a photo of your dad walking you down the aisle, facing a photo of your groom drinking with his "buds" at the reception—a juxtaposition that portrays two totally different ideas.

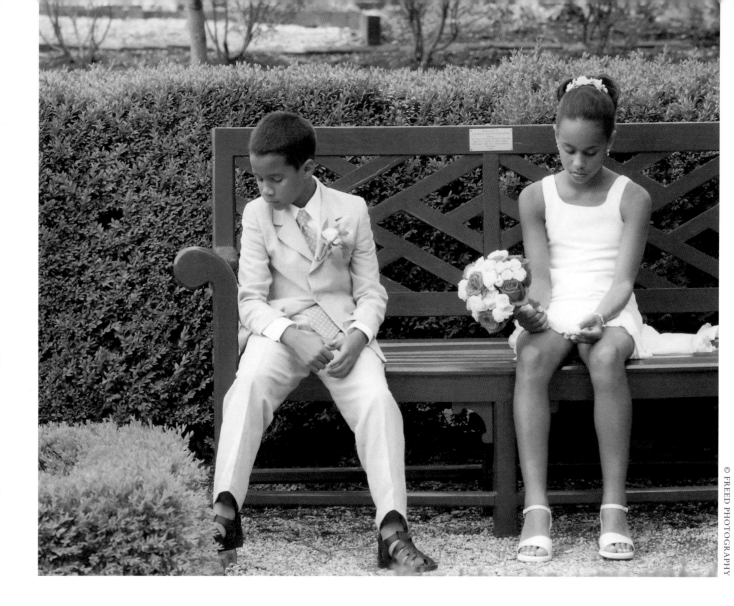

It's your wedding album and it's fun to be a designer, so go through your proofs with the thought of showing-off your big day. The more variety you can include in your album, in terms of both people and scenes, the more memorable and valuable it will become as time goes by.

On a Budget? Skip the Album Altogether!

One presentation idea that has become popular recently is having one or two dozen mounted prints that are kept in a beautiful, linen-covered box. While not an album, this type of presentation has a certain elegance to it and is both unique and economical.

Frames and Folios

Not every photograph has to be placed in your album. Perhaps you want some photos nicely framed on your walls, or sitting on a mantle, in a bookshelf, or atop a piano. Think about those images that you will want to look at every day, maybe a candid shot of you holding hands with your husband. If some images are too intimate for your living room, they may be better suited for your bedroom. Framed pictures can be as meaningful as those in your album. You might even want to create a "wedding wall" filled with timeless photographs, something your children will love to see in years to come.

Frames should match the photograph, not your décor. You want to see the photograph first, not the frame. Black and white photographs look best in silver, black, pewter, or perhaps a china or glass frame. Photographs do not always have to be matted, either.

© JAN PRESS PHOTOMEDIA

Large photographs (16 x 20 inches and up) are a classic way to capture the spirit of your wedding day. In years past, large prints were often traditional—full length, posed with your train showing, looking at the camera. More recently, depending on the images available to you, many brides are choosing a more candid shot that has special meaning to the newlywed couple: a special smile, a stolen glance, or a hearty laugh.

And just as with albums, framed photos will last longest if they are finished with a protective lacquer spray. Remember that photographs should never be located in direct sun; that is the surest way to ruin an image.

Folios are frame-type holders for photos that fold into two (book style) or three (wing style) segments. Each display face of a folio may be designed to present one or more photographs. One popular format for wing style folios is to show a large photograph in the middle with smaller photographs on each side. The folios may be arranged on dressers, tables, or other spots around your home. They make great gifts for members of the wedding party, or, for that matter, anyone who cares for you.

The tangible objects from your wedding day are items that spur your memory, preserving the enjoyment of this special day for years to come. Have fun while choosing your prints, designing your albums, and framing your favorite shots.

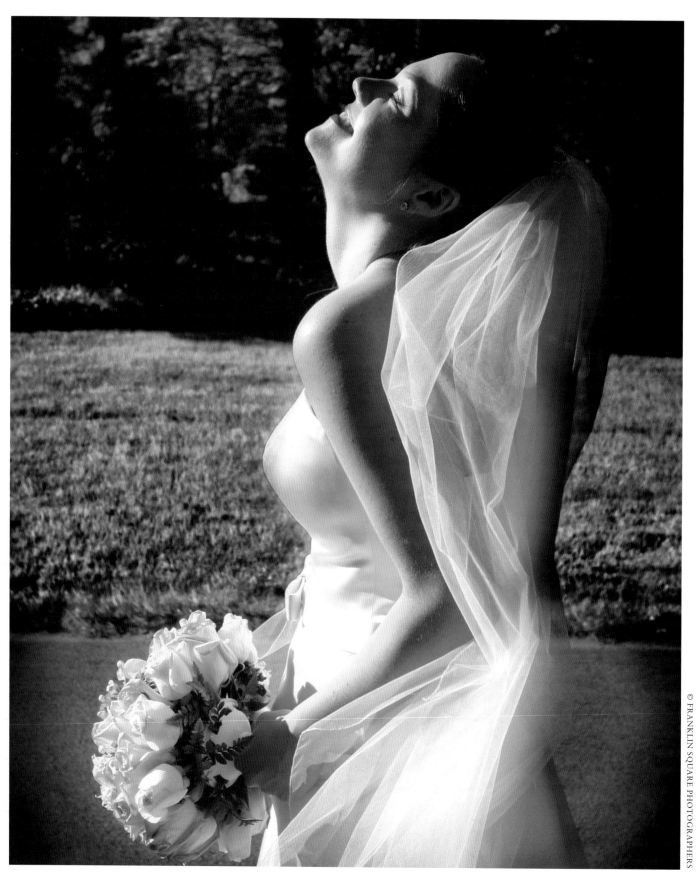

Choosing Your Photographer & Negotiating the Price

H ow will you decide whom to choose as your photographer? An important part of your decision depends on the type of wedding style you are most comfortable with.

Wedding Photography Styles

Until the mid 1940's, wedding photography as we know it today did not exist. If you wanted wedding photos, you went to a photography studio to shoot formal portraits. There, the photographer posed you in your bridal gown and your husband in his Sunday finest for a few photos. Pictures were generally not taken at the wedding. These days, however, you may consider yourself lucky, because two basic styles of wedding photography have evolved over the past half-century.

Some brides and grooms feel that too much posing destroys the spontaneity of the day, while others prefer traditional, posed photographs like the ones in their parents' wedding albums. Neither is right or wrong, just make sure that your photographer shoots in a style that you like

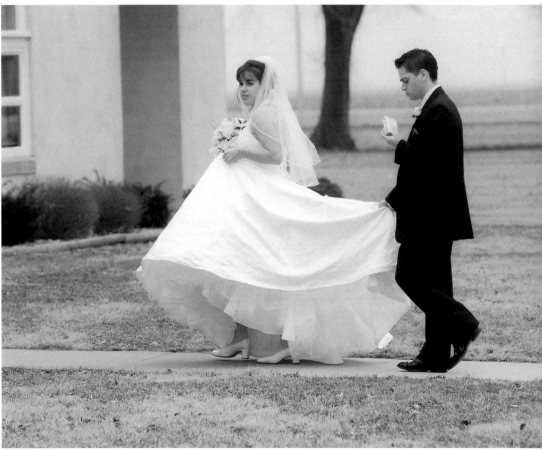

© MARK ROMINE

Traditional Wedding Photography

Traditional wedding photography consists primarily of a set of posed photographs. Even in some of the so-called unposed instances, the photographer often gives the subject modeling advice or direction. The photographs are done in a classic style. For example, a photo of the bride and groom dancing as both subjects are told to look at the camera. In the traditional style, the subjects have big smiles, and someone has made sure to adjust the man's boutonnière or the bride's veil. There is no doubt that this type of tight direction can sometimes intrude on the moment.

At the reception, it is very hard to get spontaneous photographs if the bandleader has been instructed to announce such activities as your entrance, the first dance, the cake cutting, and the bouquet toss. At the same time, it must be remembered that those announcements help keep the events organized as well as make each one special.

You may not have time to appreciate fine details like these exquisitely presented pieces of cake, but a picture like this could be right out of a magazine, making a unique addition to your wedding album.

While some brides and grooms feel that too much posing diminishes the spontaneity of the ceremony and celebration, it is true that the couple may benefit from the experience of others who regularly deal with weddings. In certain instances, the control exerted by wedding "professionals" (the maitre d', other reception staff, photographer, bandleader, etc.) is a good thing. I have seen brides demand that the cake-cutting take place at the very end of the evening. It never occurs to her that it might take 45 minutes just to dismantle, slice, and serve a multi-tier cake.

Usually these people who seem to be commanding your every movement actually have your best interest in mind. The clergyman hurries the receiving line so you won't be kissing guests for two hours, or the maitre d' is thinking about the timing of the desert he has to serve to all of your guests. Even the photographer, who pushes for a family portrait before dinner, knows that it will take a lot longer to round everybody up and get them presentable once the party has gotten fully underway.

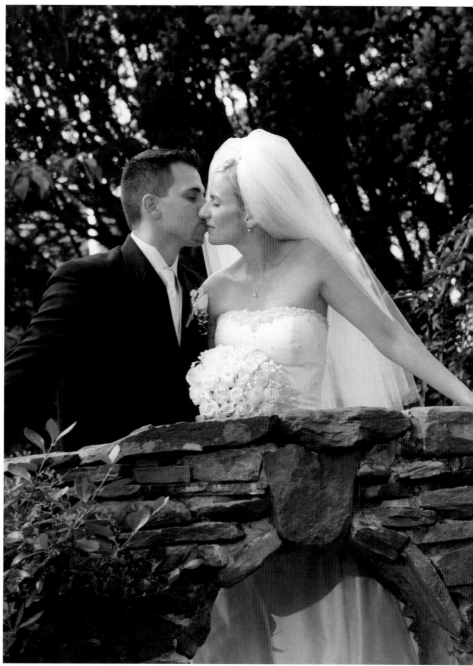

© PHOTOGRAPHY ELITE INC.

For some, the posing, scheduling, and direction result in just the kind of wedding photography they want. It is comfortable, safe, traditional, and, very importantly, it generates a great variety of photos that are sharp and well composed.

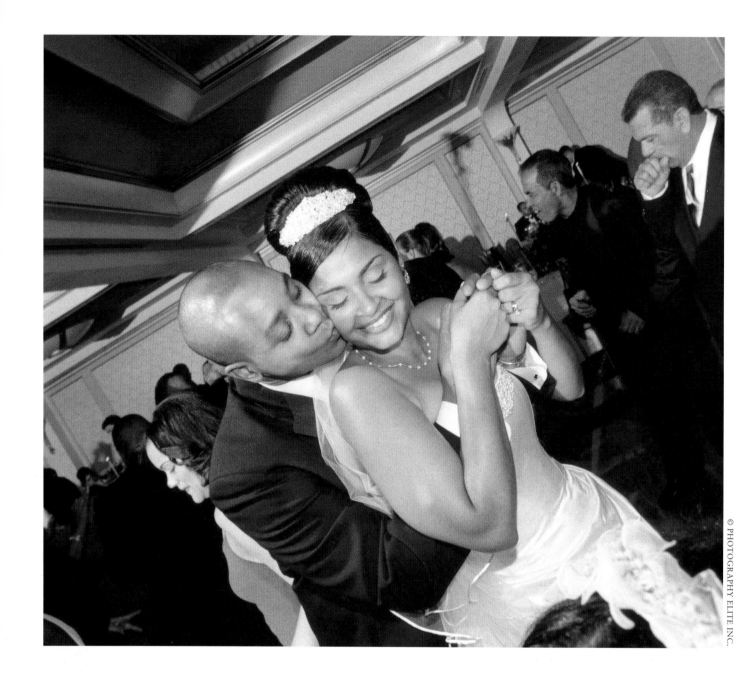

Photojournalistic Wedding Photography

A number of brides and grooms prefer a less formalized style. They define good photography not in terms of centered, smiling faces beaming directly into the camera, but rather as portraying raw emotion, untarnished by a photographer's direction. This type of photography is called photojournalistic wedding photography (PJ style).

The PJ style is difficult to precisely define. I have asked a number of wedding photographers who specialize in this form to characterize the style, and I got a broad range of responses. If I were to distill this into one sentence, I would say it centers on the subject's lack of awareness of the camera and photographer.

Some of these responses from other photographers explained the PJ style in the following ways:

● "The camera or photographer does not intrude in any way." While I understand this point of view, I feel that you are hiring a professional photographer to notice things and use good judgement. Don't you want to be told if there is lipstick on your teeth or if your veil is starting to shift and cover part of your face?

● "The photographer shoots strictly hand-held, existing-light photos (no flash)." This can become a technical constraint with which the photographer arbitrarily burdens himself. If your wedding is on a Saturday night, in a windowless catering hall with a black ceiling, shooting with no tripod and no flash will result in no pictures!

● "Subjects look their best when they are natural." I agree, but nothing about a wedding is natural to begin with. It is not every day that a woman wears a formal gown with a six-foot train trailing behind her.

● One photographer quoted W. Eugene Smith (an acclaimed photojournalist from the heyday of Life Magazine) as saying: "Photojournalism is photography with a purpose." True, but all photography has a purpose, from the simplest baby picture to the most extravagant advertising production!

● Another photographer, Rich Pomerantz wrote: "What I am looking for at all times, even in the posed photographs, is one thing: the truth. I want my photographs to reflect truly felt emotions and moments. If I can say something to a subject to help elicit that truth,

then I will. If that interaction denies me the label of 'photojournalist', I couldn't care less, because my photograph will reflect a true moment."

I see this statement as something special. That one simple word, "truth," has great weight and importance. It might be said that every successful photograph, painting, or written paragraph reveals the truth. As Mr. Pomerantz so eloquently states, it is the photograph, rather than a label or style of photography, that is most significant. You should be looking for honesty in the photographs when making your choice of photographer, as opposed to a specific style.

© RICH POMERANTZ

Choosing Your Photographer & Negotiating the Price

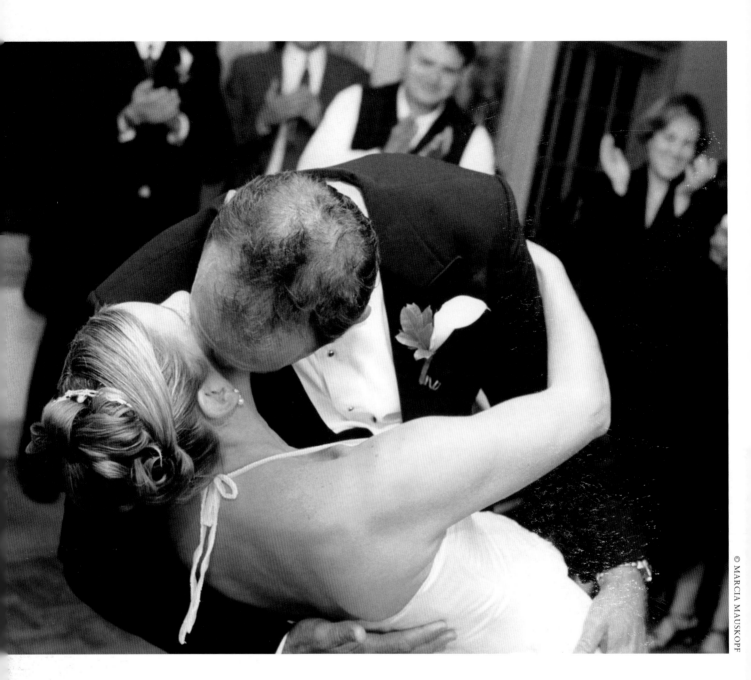

Hybrid Wedding Photography

Personally, I prefer a mixture of both traditional and PJ types of wedding photography. A posed photograph of a couple in front of the church, her train and veil perfectly swirled, a tiny sliver of white cuff showing at the bottom of his tuxedo sleeve, is beautiful. A conga-line of dancers laughing and smiling as they bump along, all unaware of the camera, is full of energy and fun. I like both equally and will shoot either. Of course it is more difficult for a single photographer to pull this off because it requires two distinctly different disciplines, and demands a versatile photographer with a wide range of talents.

The Story Is Not Always Told by People's Faces

*Although wedding photography mostly shows
the bride and groom
(and their friends and families),
unusual and interesting images reveal
themselves in other situations as well.
Details, such as a gown hanging in a sunlit
doorway, convey some of the emotions of the
day. Mixed with more traditional photos,
these types of pictures can really add to the
story you want to tell.*

© MARCIA MAUSKOPF

© MARK ROMINE

Certain Styles May Appeal to You

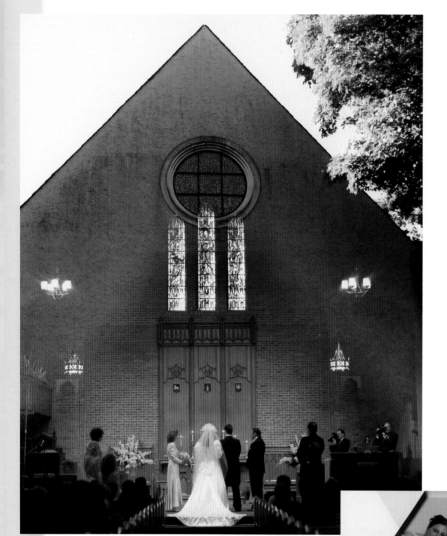

© GLENMAR PHOTOGRAPHERS

Some photographers are known for certain special effects. Examples can be seen in the double exposure (left) or the digital enhancement (below). If a specific type of photography really "wows" you when you look at someone else's wedding pictures, make sure to tell your photographer which effects you like (and make sure he or she can pull them off).

© FRANKLIN SQUARE PHOTOGRAPHERS

THE BRIDE'S GUIDE TO WEDDING PHOTOGRAPHY

What Style Should You Choose?

Knowing which style to choose is not easy. When you judge the "quality" of a photograph, what is important to you? Would you rather see all the subjects' faces? Do you like super-sharp photos? Or, do you prize most the feelings and emotions that photographs impart to you?

Some couples look at a blurry image, dripping with emotion, taken at exactly the right moment, and appreciate the timing rather than the technical considerations. Other couples look at the same image and can only see how blurry it is. What do you think?

There is no right and wrong style. Both principal types of wedding photography are equally good and both have their place and their adherents. As I pointed out, many competent professionals can even deliver both styles on your wedding day. To decide on a wedding photographer, you should determine which type of photography you appreciate the most. Then question your candidates about the kind of style they are able and willing to deliver.

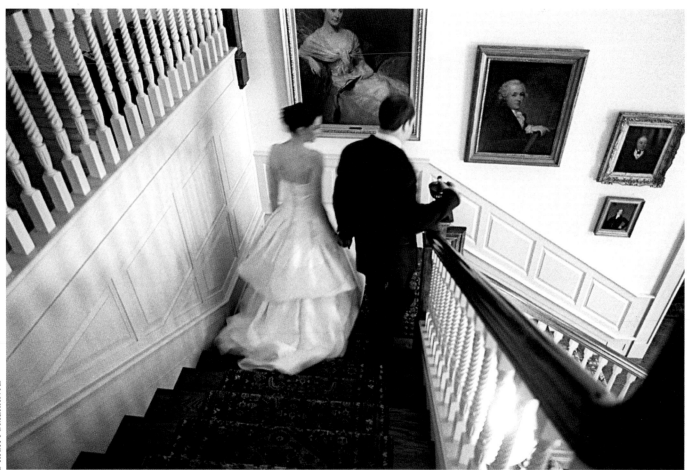

An existing-light photo like this may take time to set up, but it will be well worth the extra effort.

Finding the One

No, this is not about Morpheus looking for Neo. It is about finding your photographer. It is now crunch time. You've read this far and developed a good idea about the way in which the whole process works. You already know your likes, dislikes, budget, and the photographers' perspectives. That means it's time to get down to the nitty-gritty of selecting your photographer and negotiating your best price. So let's look at these final steps of the equation.

The search begins by compiling a list of the likely suspects. Getting that list together starts with gathering information from many different sources. In order to both choose your photographer and negotiate a fair price, you need to ask questions and perform research.

If your budget can cover the fees of a professional (see the section on costs), start your search by looking in the yellow pages for local photographers. Likewise, try a Google search (www.google.com on the Internet) under "wedding photographers." Just add a comma and the name of your state or city to find local talent. Hiring a photographer from out-of-town will add considerable expense to the total bill, but the added cost might be worthwhile to get a specific photographer.

Every studio you visit will only show you their best work and, although it is always impressive, remember it is designed to sell their product. I knew a very successful wedding-photography salesman who was always on the lookout for a "sample-book" bridal couple. He would show pictures of this human "Barbie" with her adorable "Ken," and weave his words into beautiful phrases during a presentation that made a full-figured, 5-feet tall, starry-eyed young lady see herself as one of these idealized brides. Remember the cautionary advice, "Let the buyer beware!"

Ask Around

Understand that you have other, more objective and reliable resources on your side. The first place to check is with friends and acquaintances. Chances are good that you are not the first woman on your block to get married. In this instance, "your block" is pretty big and includes family, friends, co-workers, members of the clergy, and even your caterer! All of these people are an invaluable resource. Ask everyone which photographer they've used and whom they would recommend. Then take it one step further: every time you hear a rave review, ask to see the photos. Don't think for even a moment that this is an intrusion. Everyone loves to show off their wedding photographs!

© MARK ROMINE

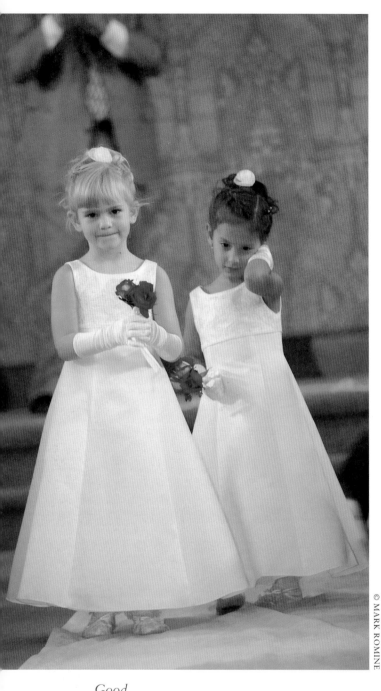

Good photographers should be able to make even the smallest members of the wedding party feel at ease.

© MARK ROMINE

As you look at the photos, listen carefully to the couple's commentary about the pictures. If you hear, "I can't believe he got this picture," or, "I asked her to take this photograph and I'm so glad she remembered," your ears should perk up. Compare the photos with your envisioned wedding plans. Be observant and realistic. If your wedding reception is an evening dinner in a banquet hall that has no windows, don't expect a fair comparison from photos of an afternoon wedding on the lawn under a tent. If the architecture of their church is modern with great expanses of windows, don't expect your photos, taken in a dramatically dark cathedral, to look like theirs.

There is one photo location over which you do have some control, and that is the where your formal shots will be taken. If you see an especially lovely background in the sample photos, ask about the setting. And if it's not a public park (sometimes private organizations or botanical gardens allow wedding photography on their grounds), find out if you need a permit or permission to be photographed there.

Many catering halls have beautiful grounds with fountains and flowers that are accessible for formal photos if you are using their services for your wedding. They also often have "house photographers" who handle a majority of the weddings at these halls. They are familiar with the surroundings and can fully exploit their scenery. In addition, they are also typically familiar with the catering hall staff, schedules, and other factors, which are advantages for you in helping the job go smoothly. This does not mean that a creative, outside photographer isn't able to walk into a place for the first time and capture beautiful images, but using "house photographers" is worth considering.

Don't Overlook Your Own Observations

When you're a guest at weddings, watch the photographers. Are they attentive? What about their appearance—do they look neat and well dressed? Does it look like they care? Do they seem personable? Some photographers seem to be everywhere while others seem to be never there. Obviously you want the everywhere variety!

If you happen to be a member of someone else's bridal party, you can observe even more closely. Was the photo shoot fun or a real drag? Is the photographer the kind of person you want to spend the day with? Pay particular attention to how he or she deals with the bride and groom and the entire bridal party. If he is busy selling himself to you for your upcoming marriage and neglects his first responsibility— the current bride and groom— he'll probably do the same thing at your wedding!

Remember that your photographer will be around you much of the day. Pick one with a personality that makes you feel comfortable, otherwise it can be a very long day!

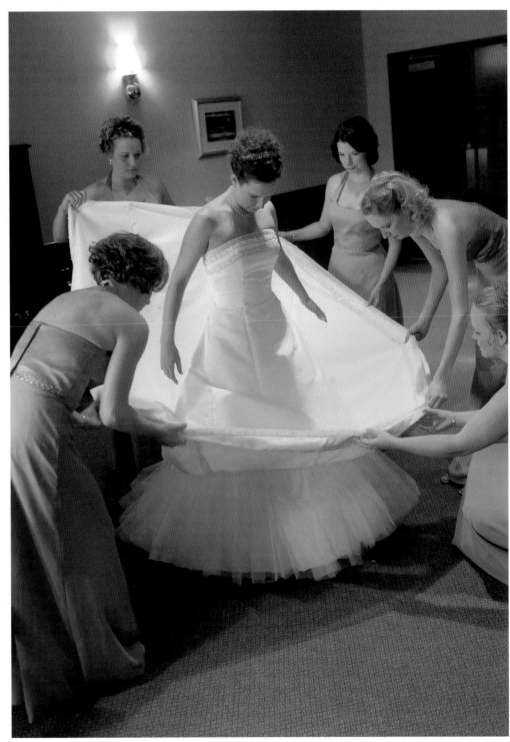

© MARK ROMINE

© MARCIA MAUSKOPF

© FRANKLIN SQUARE PHOTOGRAPHERS

Photographers May Shoot for More Than One Studio

Many studios, especially those in larger towns and cities, have a number of photographers who shoot for them. Some photographers also shoot for more than one studio. When you see one of the "everywhere" photographers who impresses you, ask for their card. Since the card may only have the name of the studio on it, make sure you write the photographer's first and last name. If you are impressed with a particular photographer's style and personality, you should request that he or she shoot your wedding when you meet with the studio salesperson.

Not all photographers are created equal. Some can take magnificent photographs, but their egos and personalities are so overbearing that their fabulous photos aren't worth the hassle. Meanwhile, some of the "nicest" photographers, who would make great neighbors and friends, may have limited talent with a camera.

Over the years I have shot for both myself and as a freelance subcontractor for wedding studios. I have worked with a full range of personalities and have also trained many young wedding photographers. While some of my protégés have grown into respected photographers, many didn't make the cut. Great wedding photography requires more than just great technical virtuosity or a winning personality. Speed, organization, intuitiveness, people skills, ability to work under pressure, and empathy are also important attributes. Ideally, you want great photographs, but you also want to have a great time!

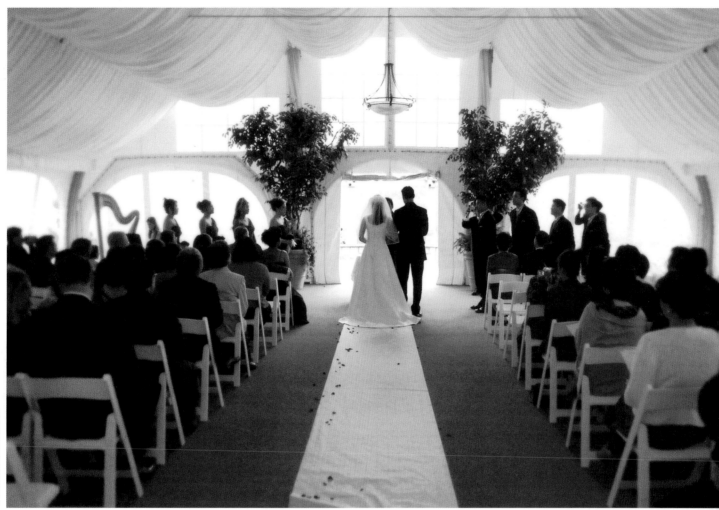

Start Looking Early

Sadly, there aren't always enough great photographers to go around. While you can almost always find a willing person with a camera, don't expect the best photographer in your area to be available for a Saturday night in June if you wait until mid-May before you start to look. The same holds true for a September wedding. In most areas of the country, the prime wedding seasons are mid-spring to early summer, and late summer to mid-autumn. People who want a specific photographer during these times often reserve him or her over a year in advance!

Many brides like the classic look of black-and-white photographs. If you want a certain style of wedding photography, start shopping for photographers early, especially if you are getting married during the most popular times of the year.

119

Interviewing and Choosing Photographers

Plan to interview at least three photographers before making a decision. Don't hire the first photographer you interview unless he or she has been your family's photographer on many occasions, their name has come up on almost every album that you've liked, his reputation is totally beyond reproach, or she is the only photographer within a hundred miles.

When you meet with the first photographer on your list, look at their photographs and make sure to get a copy of their pricing quotation. In an effort to close the deal on the spot, many photographers fill out a contract as they speak to you, so that it is ready for signing when they make their closing pitch. They know that many couples see several photographers and rarely return to hire one they've previously interviewed. An unrecorded rule states that the last photographer a couple interviews is the one they book. If the sales pitch feels too strong, stop! Stick to your game plan regardless of the pressure a photographer may exert to sign a contract then and there. Unless you are totally wowed by the photographs, the studio's reputation, recommendations, and the photographer's personality, continue to look further.

While some brides need to try 20 dresses before deciding that the first one was "it," others can walk into a bridal salon and immediately point to a dress and know "that's the one." The same can be said about looking for a photographer. While many people enjoy the hunting part of shopping, others look at shopping as a problem to be solved as quickly as possible. If either you or your fiancé dislike the selection process, then the other is better off interviewing photographers alone. You both can then finish interviews after you've narrowed the photographic candidates down to the last one or two.

© JERRY MEYER STUDIO

THE BRIDE'S GUIDE TO WEDDING PHOTOGRAPHY

Interviewing at least three photographers in your area will allow you to get a feel for local price structures. Not surprisingly, most photographers know what their competition charges and then price themselves to be competitive. However, there can still be differences between the price list of one studio and another. Higher quality materials may justify a difference in price, just as some additional features within a studio may add value — for example, it may have a beautiful indoor shooting area. While this feature might not be important to a June bride who is having her reception in a lavish country club, it might be very important to the February bride whose reception is in a small, cramped restaurant. For your convenience I have provided a list of questions starting on page 123 to use when you are interviewing photographers. I suggest you make a copy of the list to take on interviews.

© FREED PHOTOGRAPHY

Remember, It's a Contract!

You will be entering into a contract — a legal commitment between you and your photographer. By signing, both you and the photographer are bound by its terms. However, this contract is written by the photographer or studio, and you shouldn't be afraid to ask for additions and deletions that make it more acceptable to you. Before signing anything, look at the questions and concerns listed below to decide which are important enough to be specifically covered in the contract.

Compare Apples to Apples, Not Apples to Oranges

Comparison shopping for photographers can be difficult and confusing. It would be easy if both Studio A and Studio B offered you a 48-photograph, 8 x 10-inch album with exactly the same binding. But even in this simplistic example, there are dozens of tangible variables that are not easy to see or compare. And it is even harder to put a price tag on intangible items such as creativity, style, and a friendly disposition. Given the exact set of tangible products (size and number of proofs, type of albums, quantity of extra prints, etc.), would you rather choose a photographer who makes your skin crawl or one who makes the experience fun? How much would that single difference be worth to you?

So, while asking for prices that reflect the best value for your money, the lowest price should not be your only consideration. You need a base line in order to compare what different photographers offer.

If you know you will want to share some light moments with your bridesmaids, make sure you pick a photographer who will appreciate the fun.

Questions to Help You Compare Different Photographers:

Here are some concerns and questions to keep in mind as you interview photographers and look at their work. Some of these points should be included in your contract, and others should just be used to simplify comparisons.

1. While this may seem rudimentary, if you are comparing prices, make sure you are comparing similar items. Vinyl albums cost less than leather ones. Three hours of labor is less costly than six hours of labor, and logically, a single photographer has to be less expensive than a photographer and assistant.

2. Are the sample books you are being shown the ones that are specified in the contract? Often studios show samples of their top-tier wedding albums, but specify lower quality bindings in their starting contract. Be sure that the albums you are looking at are the same as the ones mentioned in your contract.

© MICHAEL ZIDE

3. Is the number of photographs in the sample album the same as what you will be getting? Sometimes studios show fat, 80-photo sample books, but start their contracts with 30-photograph albums. This is understandable from a marketing standpoint. Studios show their highest level of quality (at their highest price-level) in hopes to sell this product to as many customers as possible. While it is not technically wrong for the studio to use this marketing practice, be sure you know what the contract says about your purchase.

© FRANKLIN SQUARE PHOTOGRAPHERS

4. Ask how many proofs the photographer shoots at an average wedding. Some studios give a range for the number of photographs they might shoot, while others will hem and haw, saying things like, "The number of proofs is unlimited." Common sense should tell you that the second answer couldn't be true.

For weddings I shoot, the usual quantity is between 400 and 500 photos per crew (my assignments always include a second crew). I have listed about 250 different posed wedding photos in the Repertoire section of this book (starting on page 67). This list covers all the bases and reflects a large family and bridal party, as well as a number of duplicate poses. It also cites between 50 and 250 unposed, PJ-style photographs, depending on whether the crowd is quiet and sedate or is actively partying.

Use this information as a gauge for the number of proofs you might expect. A photographer who guarantees 100 proofs can come in at a con-siderably lower price than one shooting 800 to 1,000. It is ridiculous to try and compare the prices of these two photographers. This is a prime example of an apples to oranges type of comparison.

THE BRIDE'S GUIDE TO WEDDING PHOTOGRAPHY

5. Of equal importance is the type of proofing system and whether or not the proofs are included with the order (see the Tangibles chapter, page 81). I prefer traditional proofs using photographic paper, but a CD is an alternative that might be more suitable if your primary interest is to email photos. Some photographers will try to convince you that a proofless system is superior, or that traditional proofs are old-fashioned. I think these arguments create a smokescreen designed to increase a studio's profit by compelling you to buy more prints. Some studios even go so far as to stamp the face of the proof print with a copyright symbol or the word "proof." To make sure of what you are getting, ask to see a set of proofs (or even just a few out-take proofs) from one of the photographer's assignments. While you shouldn't necessarily eliminate a studio that uses a proofless system or places a stamp on its proofs, you should consider that these activities mean you will be forced to spend extra money on small prints that you wish to give as gifts or mementos.

© PHOTOGRAPHY ELITE INC.

Some photographers, especially those using a proofless system, create their cost estimates and profit structure based on the assumption that you will buy more prints than the minimum amount stated in their contract. Conversely, other photographers—often those who shoot heavily and include the unstamped traditional proofs as part of the original contract— figure their profit into the original contract as opposed to the sale of extra prints. Typically, you end up spending approximately the same amount—paying either up-front or later.

© PHOTOGRAPHY ELITE INC.

6. Ask how many hours the photographer will be with you. Find out if it is possible for you to decide on the day of your wedding that the photographer should stay longer? What are the overtime charges if you ask the photographer to stay an extra hour or two?

Here's the scoop on this: Many photographers say they will remain with you until the cake is cut, or the garter and bouquet are thrown. However, catering halls often plan these two events well before the party is over, when everyone is still fresh and the majority of guests are present. While this may sound fine, you should remember that many great picture opportunities occur after the cake is cut and the bouquet is tossed, when the partygoers have begun to let their hair down. If overtime fees are spelled out in your contract, you gain the option of keeping the photographer with you until you decide their services are no longer needed.

7. If you have a wedding that will run from early in the day to late in the evening, ask if there is a twilight charge involved. This fact of life is especially common in densely populated cities. Twilight charges are extra charges that caterers, bands, and some photographers add to parties that occupy the middle of the day during prime wedding season.

© FREED PHOTOGRAPHY

A caterer can book two weddings in his hall on a busy Saturday in June; one in the morning and one in the evening. Likewise, bands and photographers can do the same thing. If your wedding requires the photographer to be at your home by noon for a 1:00 p.m. ceremony, and then includes a three-hour layover before an 8:00 p.m. dinner, your single wedding might take the time normally required for two. The photographer therefore has to give up an opportunity for additional income.

You might decide to eliminate a photographer solely on the basis of a twilight charge. But remember that photographers who are the most in demand are often the ones who charge a twilight fee, and are also quite possibly the ones who are the best. Otherwise they probably wouldn't be so busy!

8. What type or style of photography do you prefer? Ask how many people the studio will be sending to your wedding. An assistant holding an extra flash can make dark wedding halls seem brighter. A second crew (photographer and assistant) might not double the amount of photos taken, but they will give you two different views of the same memorable moment. A PJ-style shooter, in addition to the primary photographer, can add interesting and spontaneous photographs to the coverage. Each of these alternatives is more expensive than a single photographer, but will add options in both number and style of pictures for your albums.

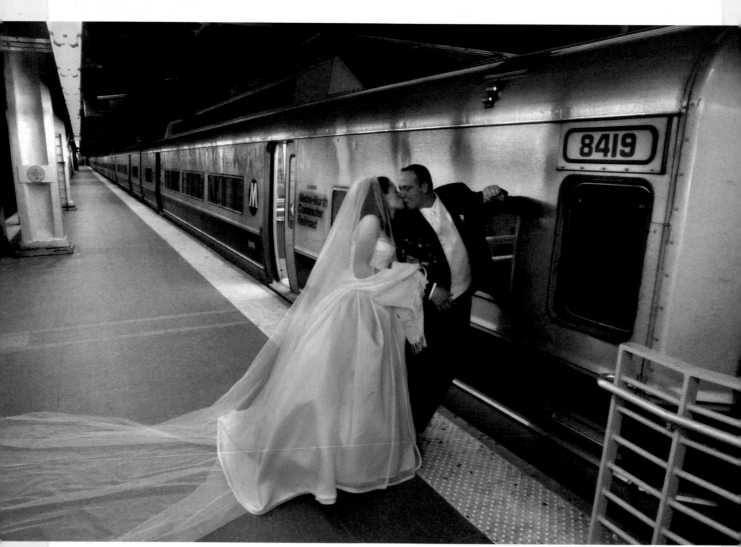

© FRANKLIN SQUARE PHOTOGRAPHERS

THE BRIDE'S GUIDE TO WEDDING PHOTOGRAPHY

9. Many studios offer an engagement portrait as part of their package—this may be a plus to you. Not only will it give you a chance to meet your photographer, it will also give you the opportunity to experience his work and personality beforehand.

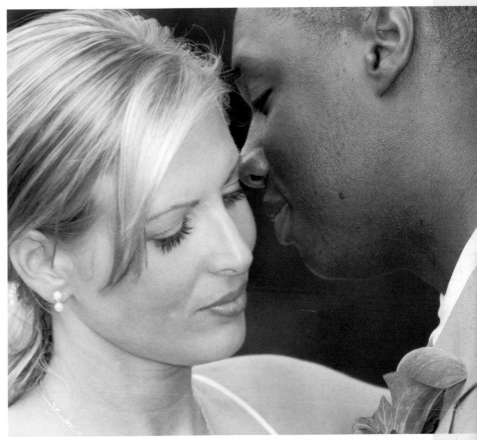

© FREED PHOTOGRAPHY

If you really like the photographer, make sure he is the one who will be showing up on your wedding day. The best way to do this is to get his or her name stipulated in the contract as the photographer. At the same time be aware that this request cannot be absolute. You are signing the contract a long time in advance of your wedding day. No one can be completely sure of the future. Sadly, a death in the family, a broken leg, or a car accident are all legitimate reasons why you may find yourself dealing with another photographer on your wedding day.

Make your request, then call to confirm a month in advance, and then again two weeks before the wedding day. But if life throws you a curve, don't let it ruin an otherwise perfect day.

10. Most studio contracts require a retainer to reserve the date. If you cancel, you forfeit the retainer. But what happens if you are really unhappy with the engagement portrait or decide that a different photographer is more to your liking? You can't expect to cancel a contract two days before a Saturday wedding in June and not be liable for its full cost. But you can request that the contract include a clause that allows you to cancel a reasonable time before the event — with the only liability being that you forfeit the retainer. Try to make sure that the contract allows you to limit your liability if you change your mind within a specified timeframe.

11. Lastly, horror of horrors, what happens if your photos don't come out? I'm not talking about being displeased with the photos. Instead, what if there are no photographs? A broken camera, a burned down lab, stolen film, or a flooded studio are only a few of the catastrophes that might take place. In my career (over thirty-five hundred weddings), none of these calamities has ever happened. Still, my contracts always state that if any of them were to occur, my liability would be limited to the return of all monies paid by the customer. If such terrible things were to happen, it is unfair for you to ask the photographer to pay for a second wedding. At the same time, you should get all the money you've paid in retainers and deposits returned to you. This circumstance needs to be covered in the contract.

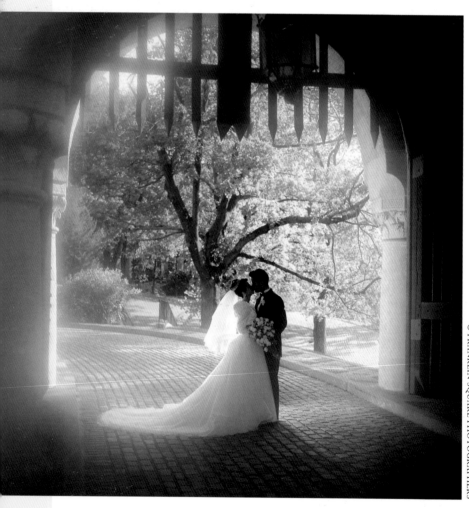

© FRANKLIN SQUARE PHOTOGRAPHERS

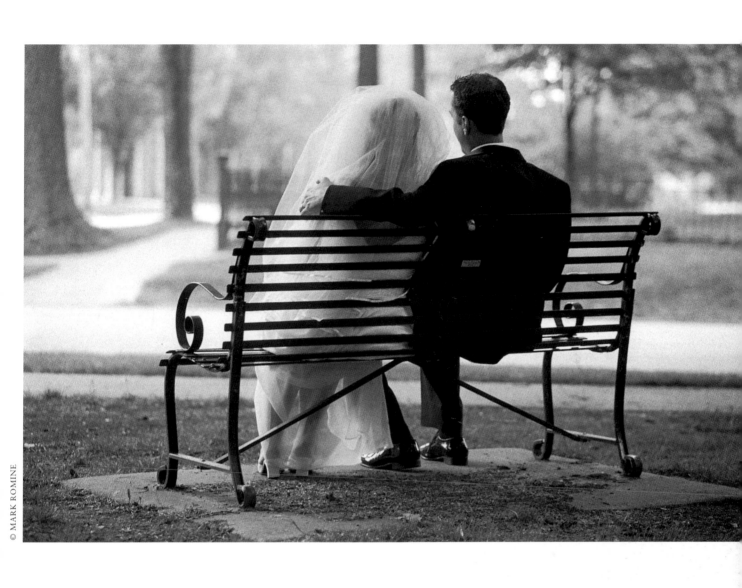

Right of First Refusal

While you want to be careful about signing a contract right away, you should understand that there is risk involved in delaying your decision. During the time that you are comparing studios, the first photographer you interviewed may get booked. Don't spread your shopping over a three-month span. Try to make all your appointments within a two-week timeframe. This gives you the advantage of keeping the information about each photographer fresh in your mind. However, if a photographer really interests you, ask if he or she will give you the right of first refusal for two weeks (or as long as it takes to see all the other candidates). This means that if someone else calls them within this 2-week timeframe for the same date, they will not accept that assignment without calling you first. In return for this consideration, you should agree to give your decision immediately if they do call. It is important to talk about this decision with your fiancé before the call comes, so that you live up to your part of the bargain.

Packages Versus À la Carte Buying: Do You Need (or Even Want) the Kitchen Sink?

Many studios offer packages that may cover everything you'll want. These packages typically include: the bridal album, two smaller albums for parents, a large portrait for hanging on the wall, a dozen wallet-sized prints, and even photo thank-you cards. If you are on a tight budget, you must ask yourself if you really need the photo thank-you cards, the wall portrait, and/or the dozen wallets? As a less expensive alternative, you may want to consider going à la carte.

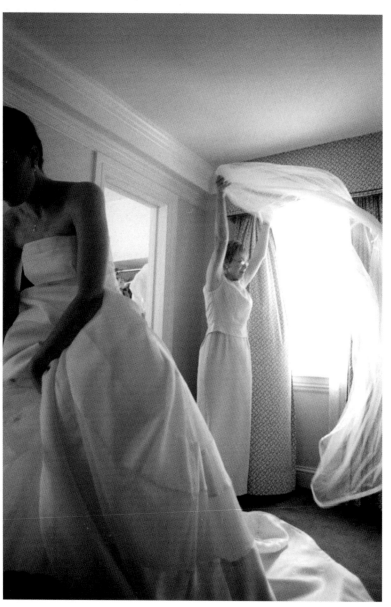

© RICH POMERANTZ

Conversely...

Some studios offer more expensive versions of their basic packages, which feature more prints and other extras. While you should ask yourself if you can really afford or use these extras, consider that many multiple-photographer studios assign the best photographers to their largest contracts. Studios are also less likely to be as watchful of the number of rolls of film shot on these bigger contracts. So, if you think you will probably add the extras anyway, you should consider committing up-front to that bigger package. Even if it doesn't offer much extra in the way of value, when compared to buying the additional items later from an à la carte menu, this method gives you more room to negotiate. Contracting for everything prior to the shoot also helps insure that you know your final costs while enabling you to be more resistant to the hard sell of extras after the photos are taken.

THE BRIDE'S GUIDE TO WEDDING PHOTOGRAPHY

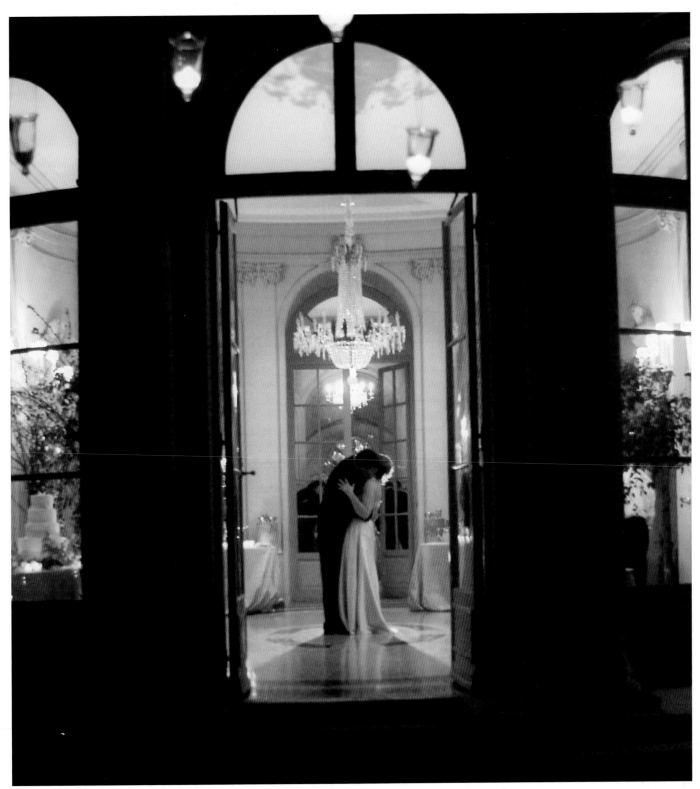

© FREED PHOTOGRAPHY

Choosing Your Photographer & Negotiating the Price

The Creative-fee Approach

Some wedding photographers include a charge known as a "creative fee." This fee is to cover their time; it does not include products or items of any type. All proofs, prints, albums, and other extras are, after the fact, additional costs. While this may seem like a bad deal and even leave you feeling as if you are getting nothing for that creative fee, often the costs for prints and albums in this system are less than those in a package-based offer. Because the profit is assured in the creative-fee approach, this method eliminates the photographer's risk that you may not buy prints later. It therefore frees him or her to concentrate on doing the best job possible without thinking about their profit margin every time they push the shutter button.

Prices Are Different Everywhere

I have avoided quoting specific prices because they vary widely depending on location, local competition, and talent. Packages can cover a broad range of products and services. And overhead, which photographers must consider in their pricing structures, can be vastly different between New York City and Butte, Montana. An assistant photographer can cost $175 in New York, while a photography student in Butte might do the same job for $25.

Competition within a mid-sized city with 100 photographers could easily create a shoppers' paradise, while prices might be higher in a smaller place where a single photography studio is the only game in town. That mid-sized city with 100 photographers might be able to support all the vendors a photography studio needs (camera stores, labs, binderies, retouchers, etc.) within a stone's throw. Meanwhile the photographer in an isolated town might have to add $200 to every order just to cover the shipping to and from his vendors.

© PHOTOGRAPHY ELITE INC.

Talent, reputation, and personality are also intangibles that are very hard to quantify. Some wedding photographers charge $500 for an hour of their time while others will happily work that same hour for $50. Importantly though, the distinctions are sometimes worth the differences in price!

If you are spending $50,000 or more for your wedding, it is silly to quibble over a few hundred dollars extra to hire a photographer in whom you have the utmost confidence. However, if your entire wedding budget is limited to $3000, you must give careful consideration to a cost differential of $300, which represents 10 percent of your total budget.

There are significant differences in what photographers' charge for various services, and you probably have a range in your budget to work with. This is why I suggest you interview at least three local photographers before making your decision. But always remember there is no free lunch, and in almost every instance, you get what you pay for.

© PHOTOGRAPHY ELITE INC.

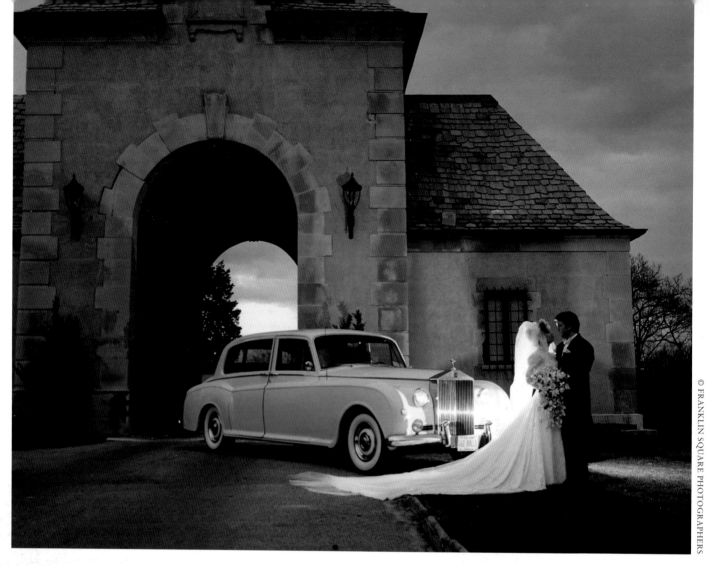

You can negotiate, but remember that getting beautiful pictures like these ultimately may be far more important to you than a rock-bottom price.

THE BRIDE'S GUIDE TO WEDDING PHOTOGRAPHY

You Can Negotiate

Perhaps it comes as a surprise, but prices are rarely written in stone. It is not against the law to negotiate with your wedding photographer. People haggle over the price of cars, homes, and even landscaping, so why should it be different with photographers? Since wedding photographers are in a service business, they are subject to the basic laws of supply and demand. But before you go off on a negotiating frenzy, realize that you are walking a fine line between getting a rock-bottom price and creating a relationship in which your photographer wants to do his absolute best for you. It's difficult, but you want to be strong and assertive yet nice and sweet at the same time. Forgetting the nice part of the equation can have dire consequences. You might demand in the contract that your photographer take a minimum of 300 pictures, and then be quite distressed if he takes 250 of them of his shoes! Photographers are creative types and some react negatively to strong-arm tactics. The answer lies in always negotiating with a smile on your face and an understanding that you can gain much by having your photographer happy with the deal, too.

When the day is over, you should be pleased with your photographs without breaking your budget.

© MARCIA MAUSKOPF

Sometimes it pays to pause a second to catch your breath. If you are comfortable with your photographer, a break from the action can yield some interesting reflections on the day.

Discounts

When airline advertisements say, "Special fare rates may be subject to certain limitations," they mean that their low-priced tickets are available if you are willing to accept conditions and limitations on your schedule. Similarly, if you are willing to get married in the off-season, you can save a lot of money. In the dead of winter or in the wilting heat of summer, when there are fewer weddings, you may find many photographers who are willing to give you a discount in order to book for a slow day. Remember, the off-season for weddings runs from November through April and from July through August. Those are the best months to look for the best rates. If you decide to get married in mid-February (the slowest time in the slow season), you may find yourself with a choice between many of the best photographers in your area.

Interesting architecture and structural details, such as the archway, brick road, and tiled roof in this photo, often create a memorable scene for a romantic picture showcasing you and your groom.

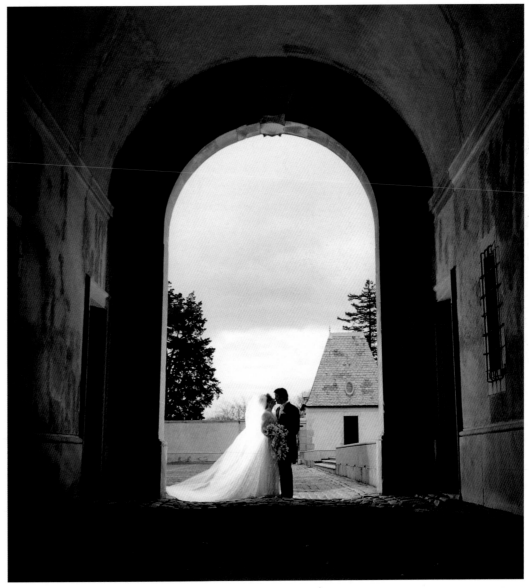

© FRANKLIN SQUARE PHOTOGRAPHERS

Choosing Your Photographer & Negotiating the Price

This type of leverage may also exist for weddings on weekday nights and the first or last day of long holiday weekends. While virtually all the photographers in town will be working every Saturday and Sunday throughout the peak wedding season (May, June, September, and October), few will have every Friday night scheduled. If you are on a tight budget, don't overlook these possibilities because you can also negotiate favorable prices with florists, bands, DJs, caterers and other wedding service providers. Booking a Friday night wedding in winter represents found money for all the wedding vendors you will be dealing with.

If you like an unusual or artistic look such as increased grain or the soft look of black-and-white infrared film, ask about it when you interview photographers.

THE BRIDE'S GUIDE TO WEDDING PHOTOGRAPHY

New studios in need of both assignments and samples may offer lower prices. Sometimes photographers will decrease their price to gain entrée into a new community, hoping that the exposure will result in more assignments that will help expand their customer base.

Do not misunderstand and think photographers will cut their price in half—you should be leery if they slash that deeply since they would be forced to cut corners to make a profit. All photographers must be profitable to stay in business. But if you find one studio is offering the services and prices you want, show these estimates to other studios and ask if they can match the price. It is often true that "the squeaky wheel gets the grease." If something is important to you, ask for it. If those 100 photo thank-you cards are a deal-breaker on a $3,500 wedding photography contract, very few studios will let your assignment walk out the door without negotiating.

Your wedding photographs are very important, but so is the hard-earned money you are spending. If you shop wisely and apply some of these suggestions, you will be happy with your wedding pictures and still be able to afford that new washer and dryer! Good luck, you are now informed and ready... go get 'em tiger!

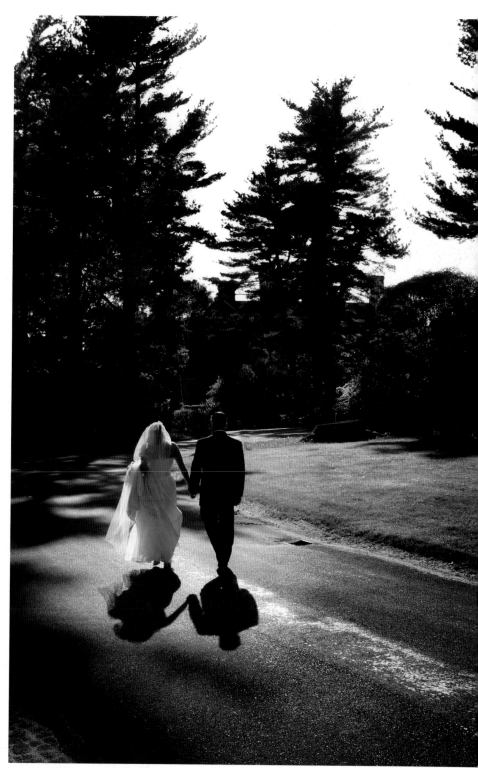

© FRANKLIN SQUARE PHOTOGRAPHERS

Choosing Your Photographer & Negotiating the Price

INDEX

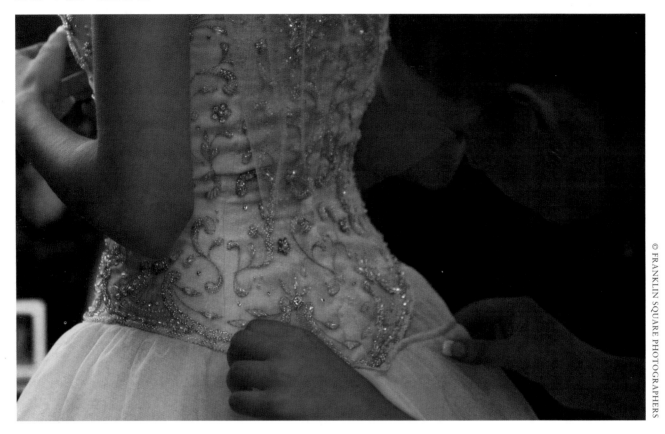

© FRANKLIN SQUARE PHOTOGRAPHERS

D

E

F

G

H

I

L

M